Color your world

101 Amazing coloring designs

Stress relief book for adults

By Erin Adams

Copyright©2016 Erin Adams

All Rights Reserved

Copyright © 2016 by Erin Adams

All rights reserved. No part of this publication may be reproduced, distributed, or transmitted in any form or by any means, including photocopying, recording, or other electronic or mechanical methods, without the prior written permission of the author, except in the case of brief quotations embodied in critical reviews and certain other noncommercial uses permitted by copyright law.

Disclaimer

While all attempts have been made to verify the information provided in this book, the author does assume any responsibility for errors, omissions, or contrary interpretations of the subject matter contained within. The information provided in this book is for educational and entertainment purposes only. The reader is responsible for his or her own actions and the author does not accept any responsibilities for any liabilities or damages, real or perceived, resulting from the use of this information.

The trademarks that are used are without any consent, and the publication of the trademark is without permission or backing by the trademark owner. All trademarks and brands within this book are for clarifying purposes only and are the owned by the owners themselves, not affiliated with this document.

Introduction

From quiet a long time, therapists and physiologists are using coloring as the relaxation technique for their patients as it provides stress relief. Inability to focus is a symptom of stress and anxiety. Coloring provokes a relaxing outlook, comparable to what you would accomplish through meditation. Like mediation, coloring allows us to turn off our brains from other thoughts and focus on the instant. Here you will find 101 coloring pages. Enjoy coloring!

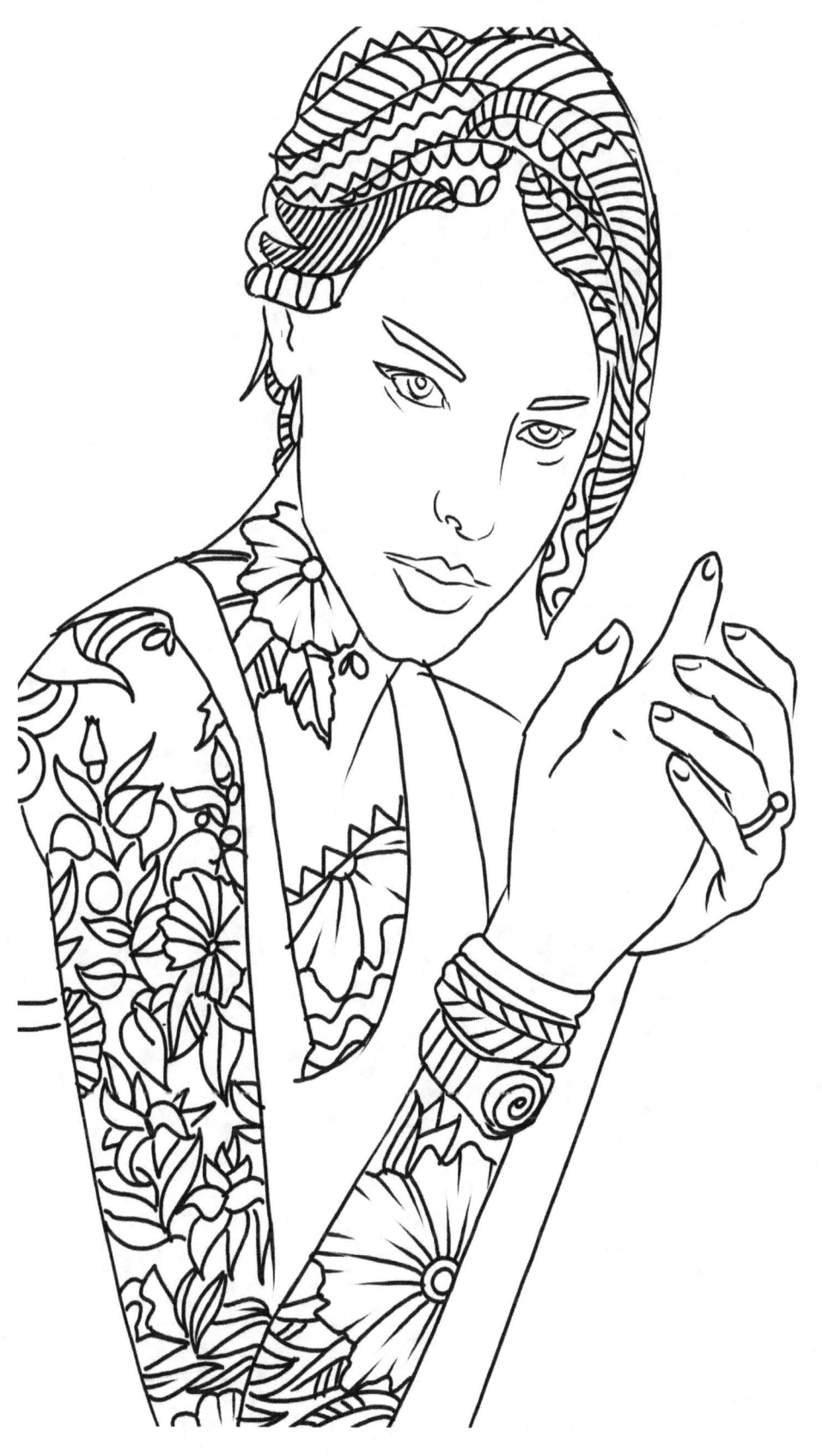

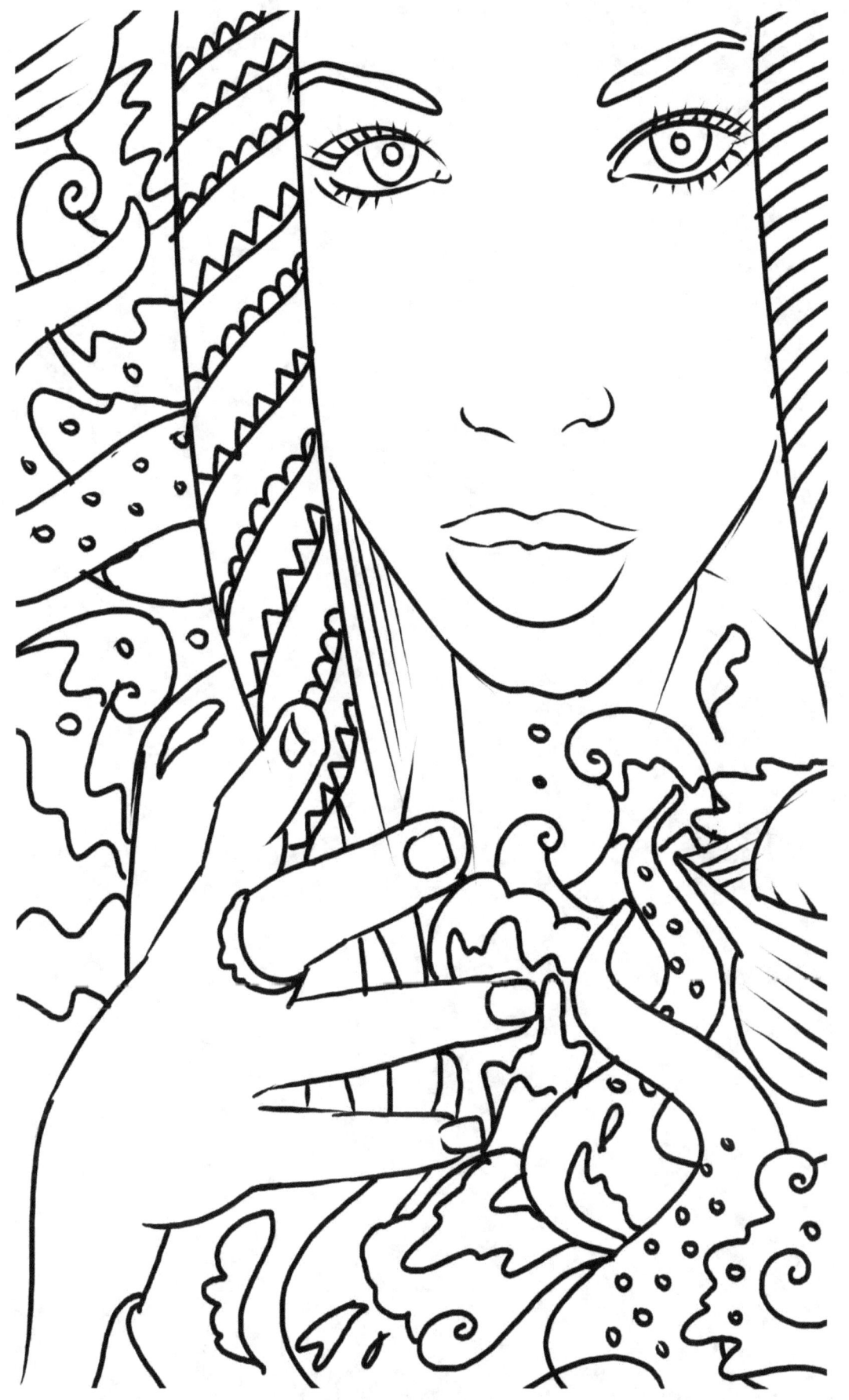

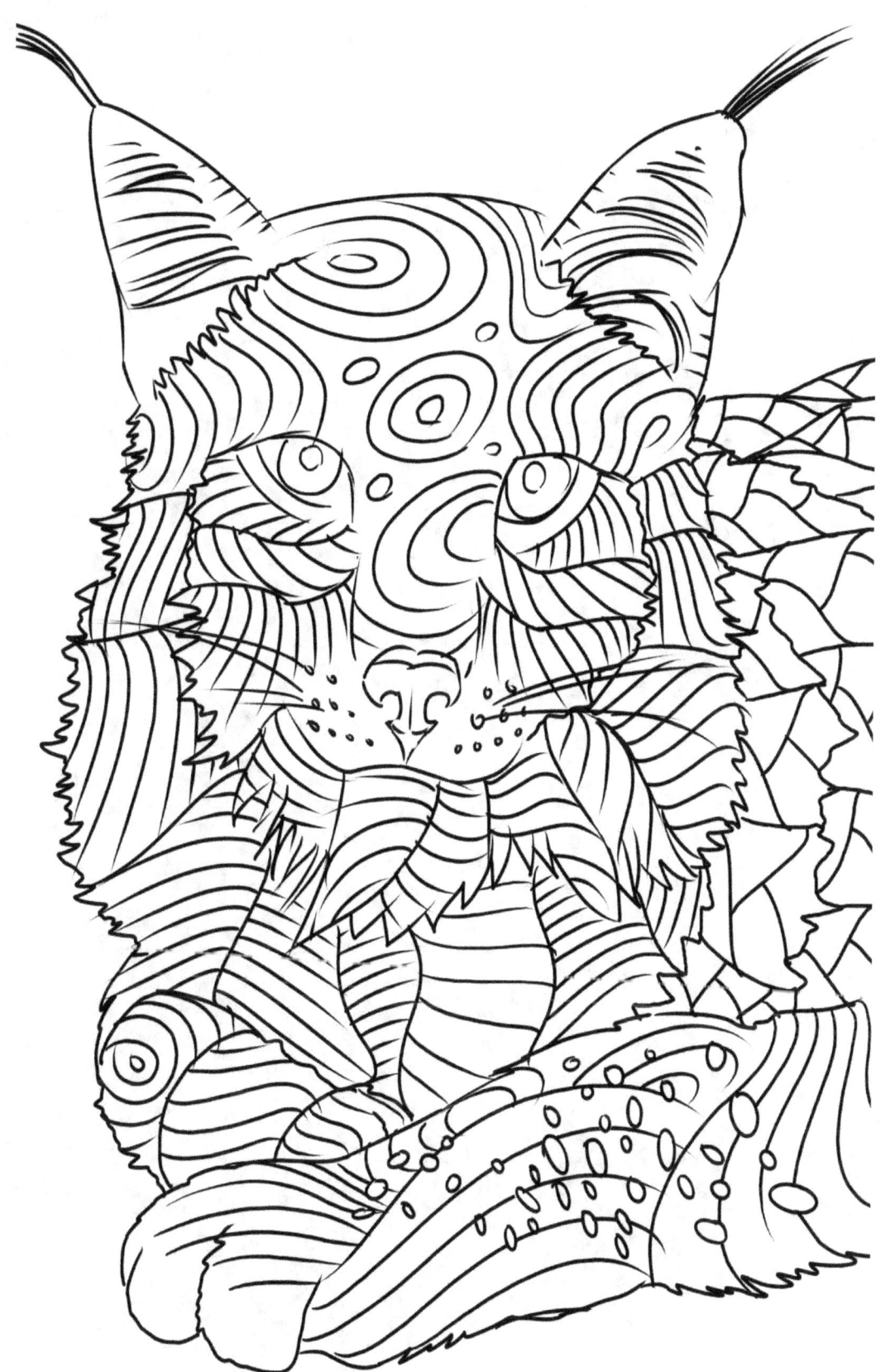

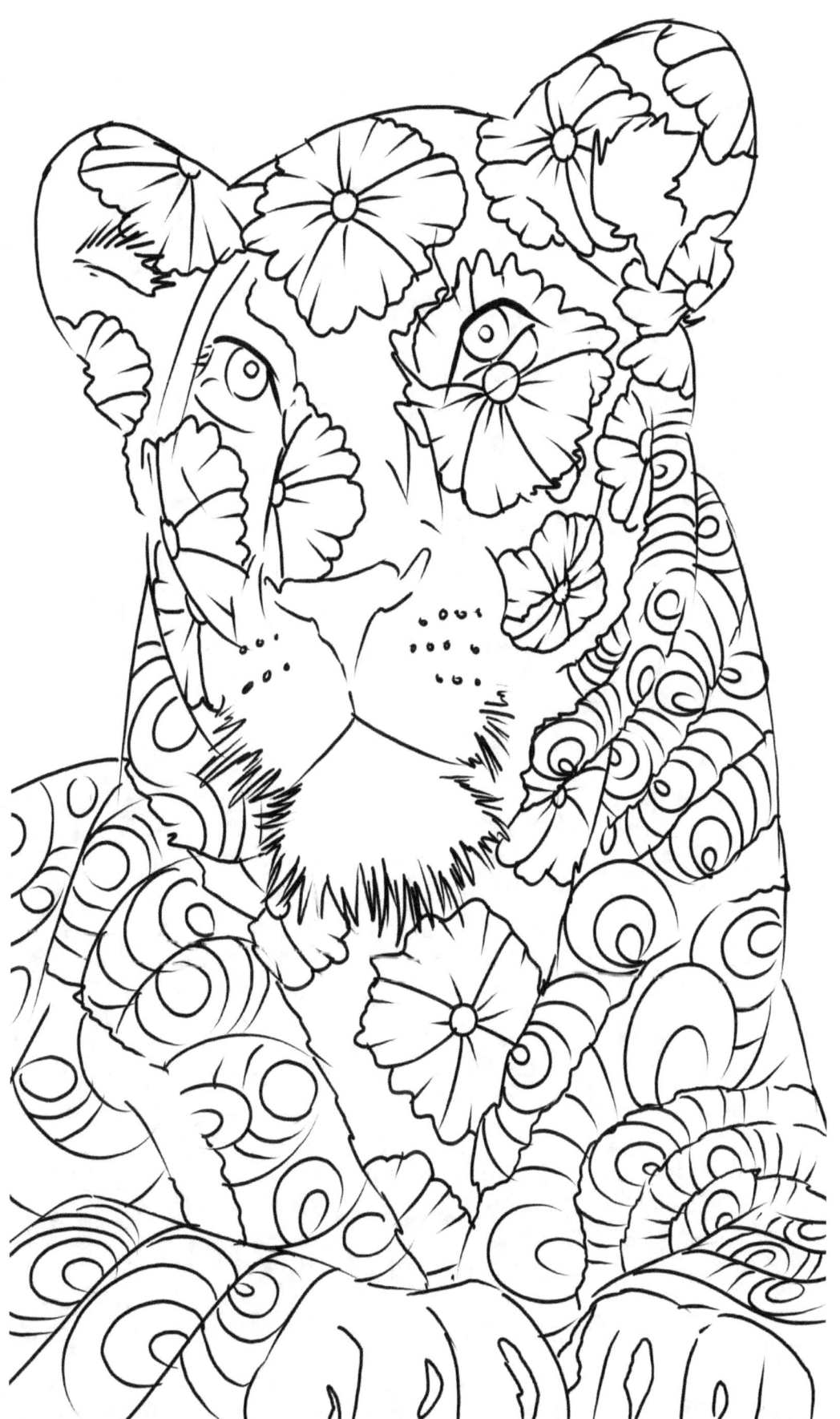

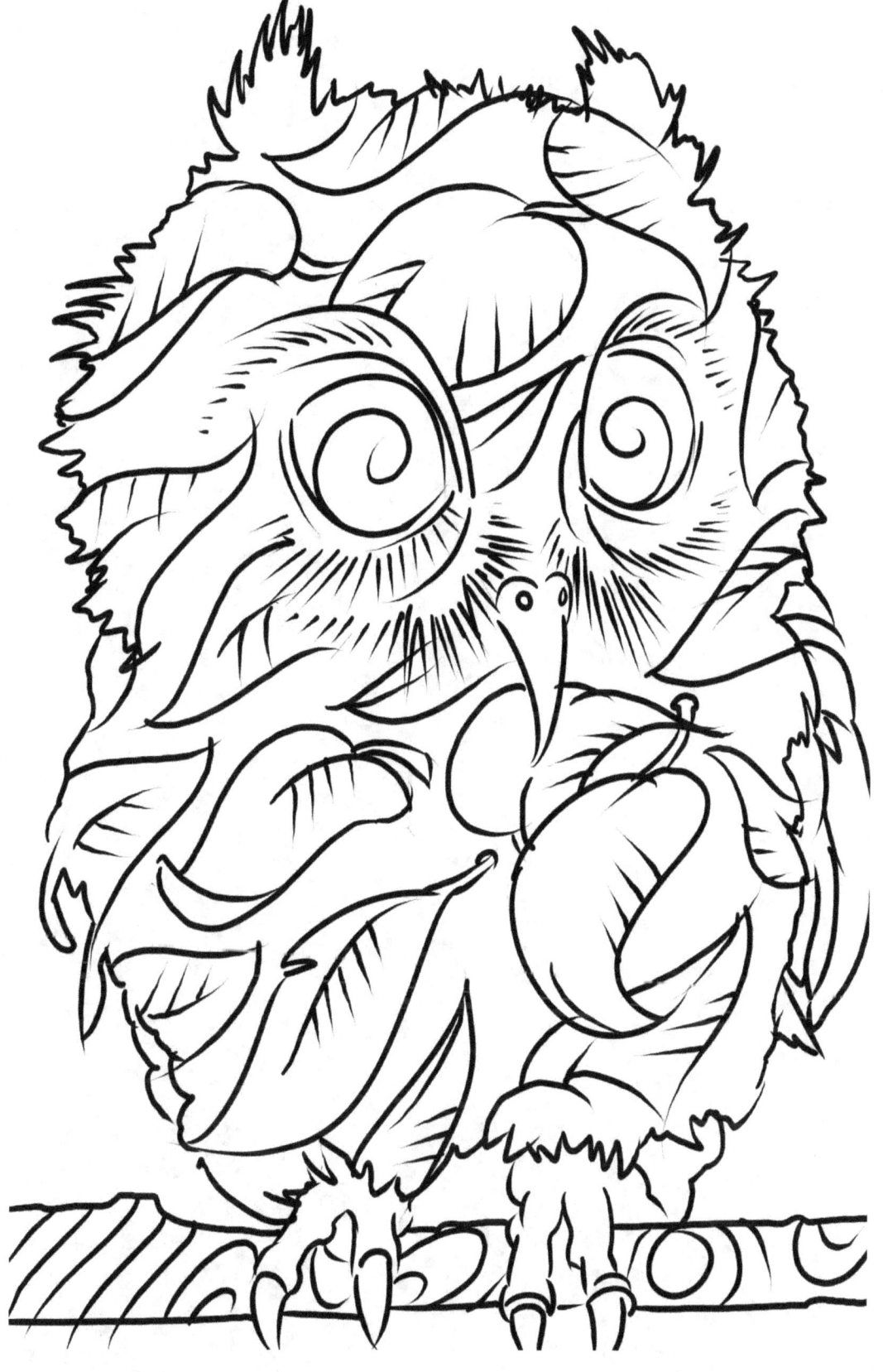

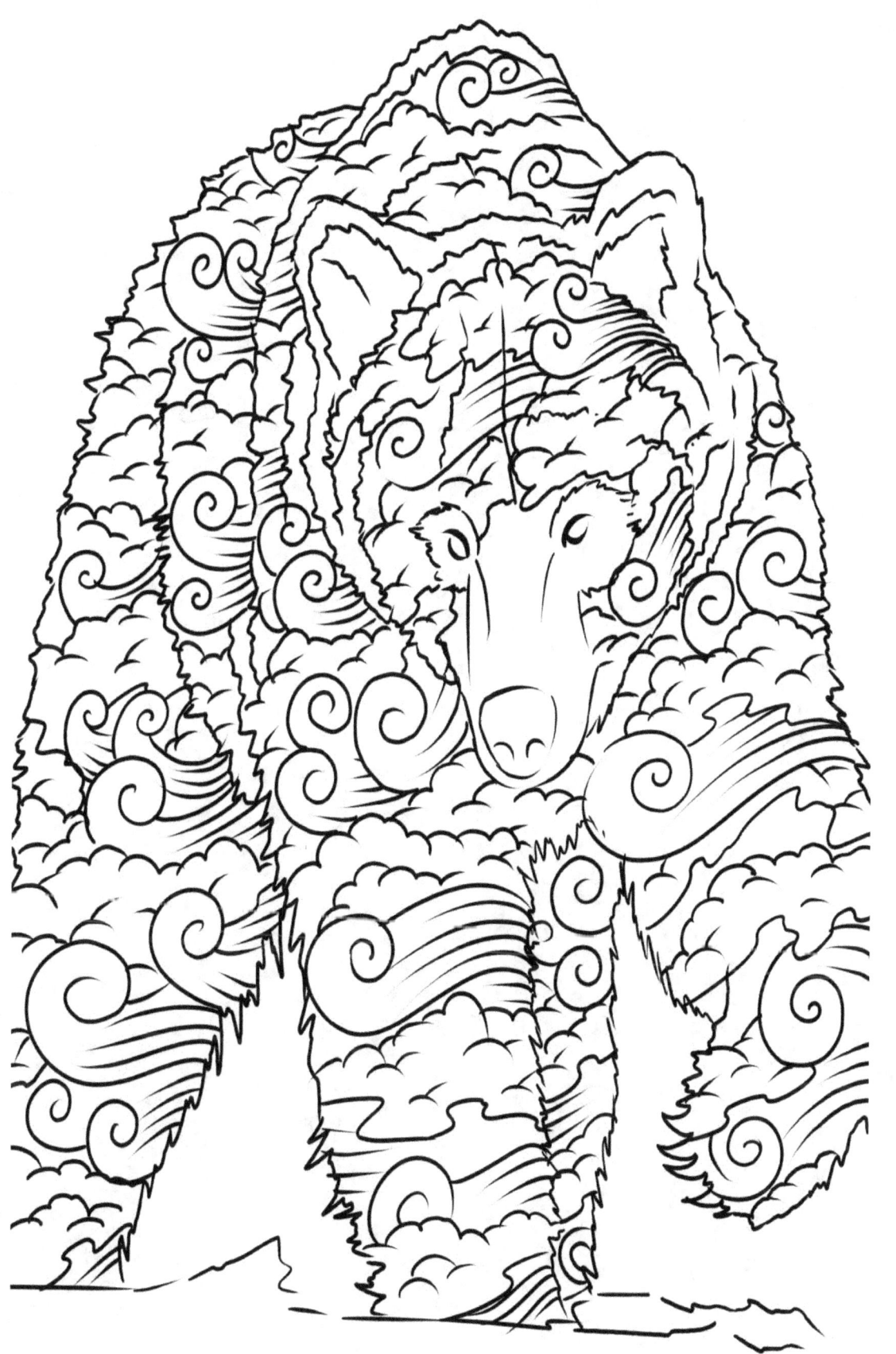

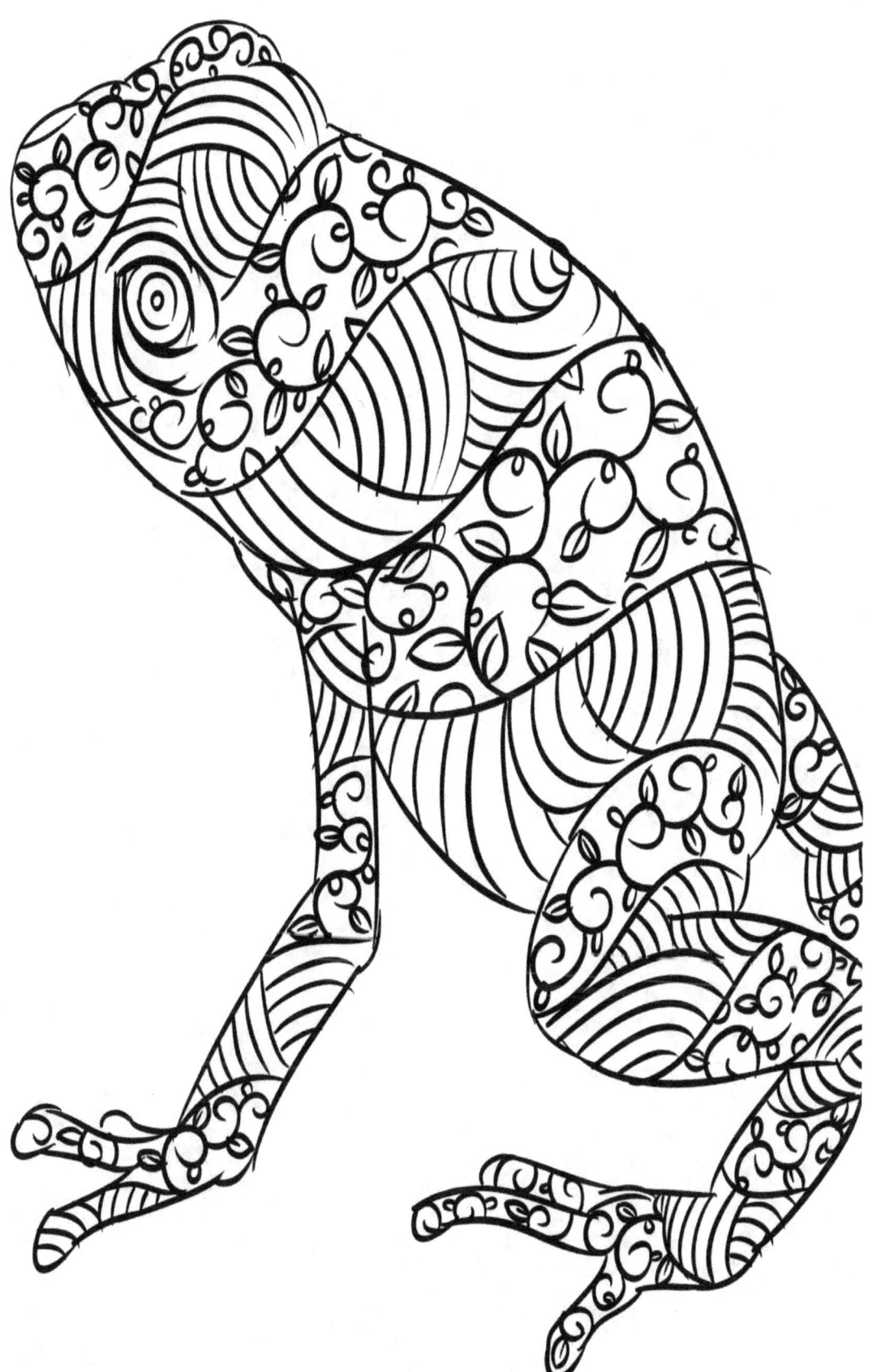

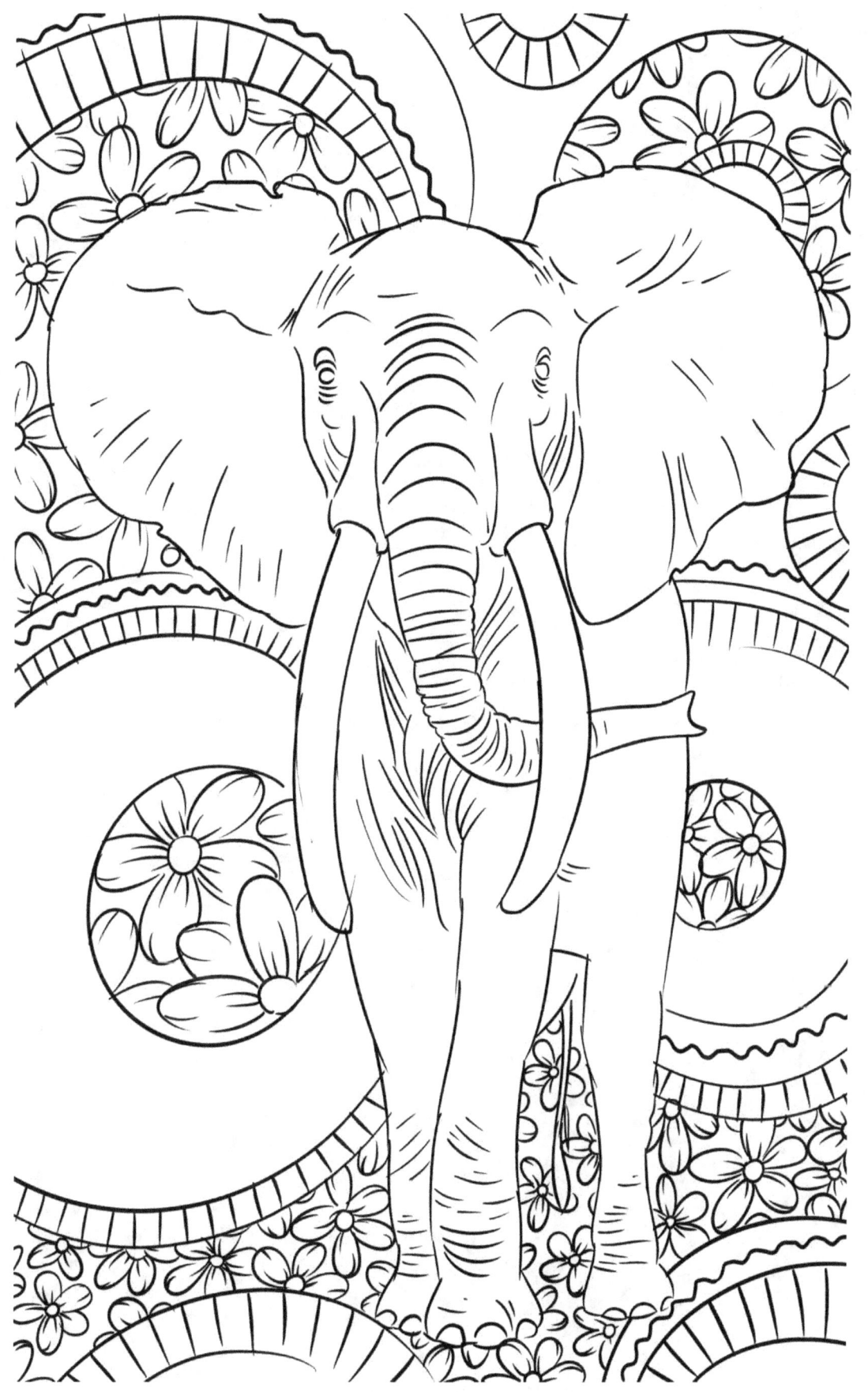

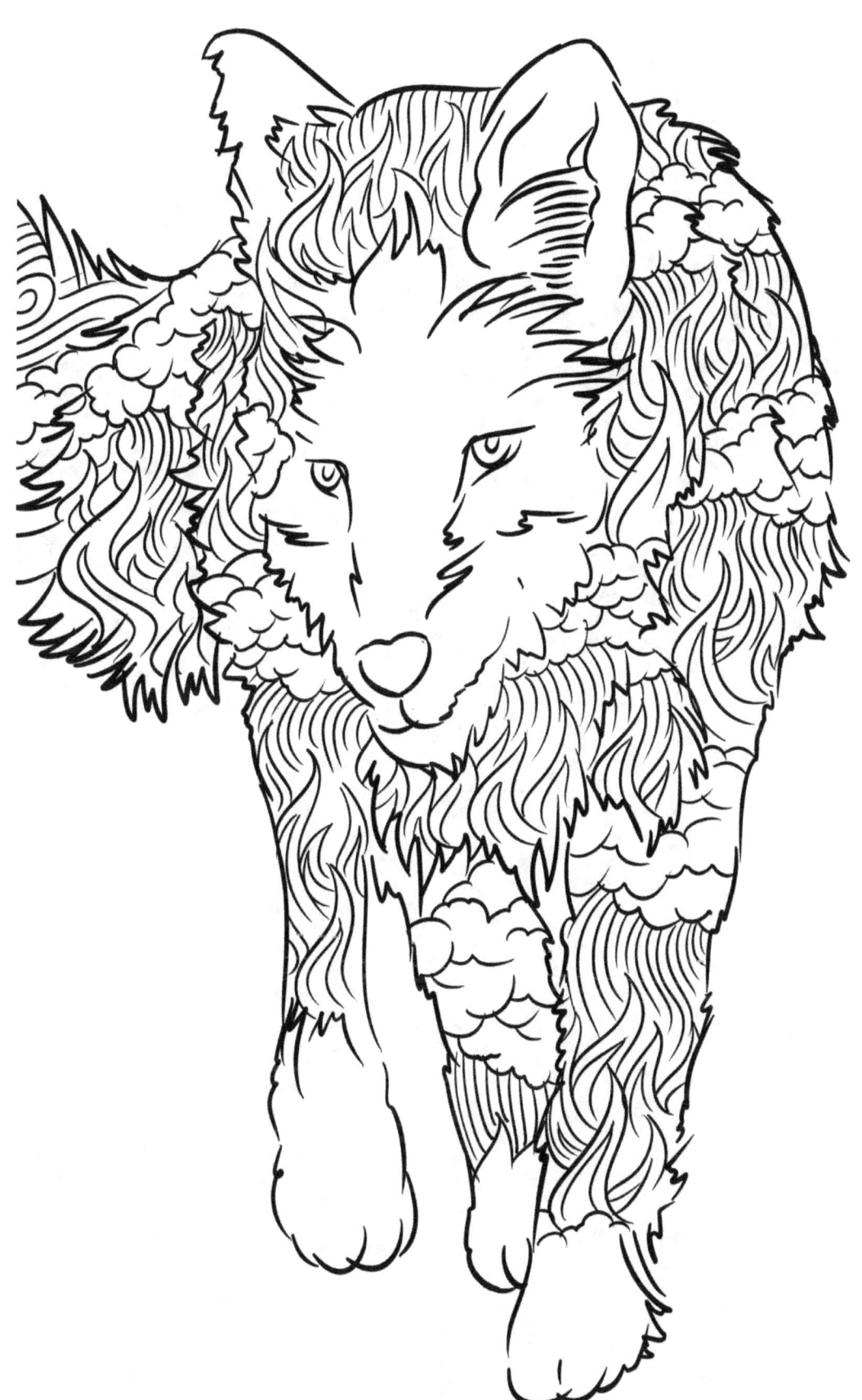

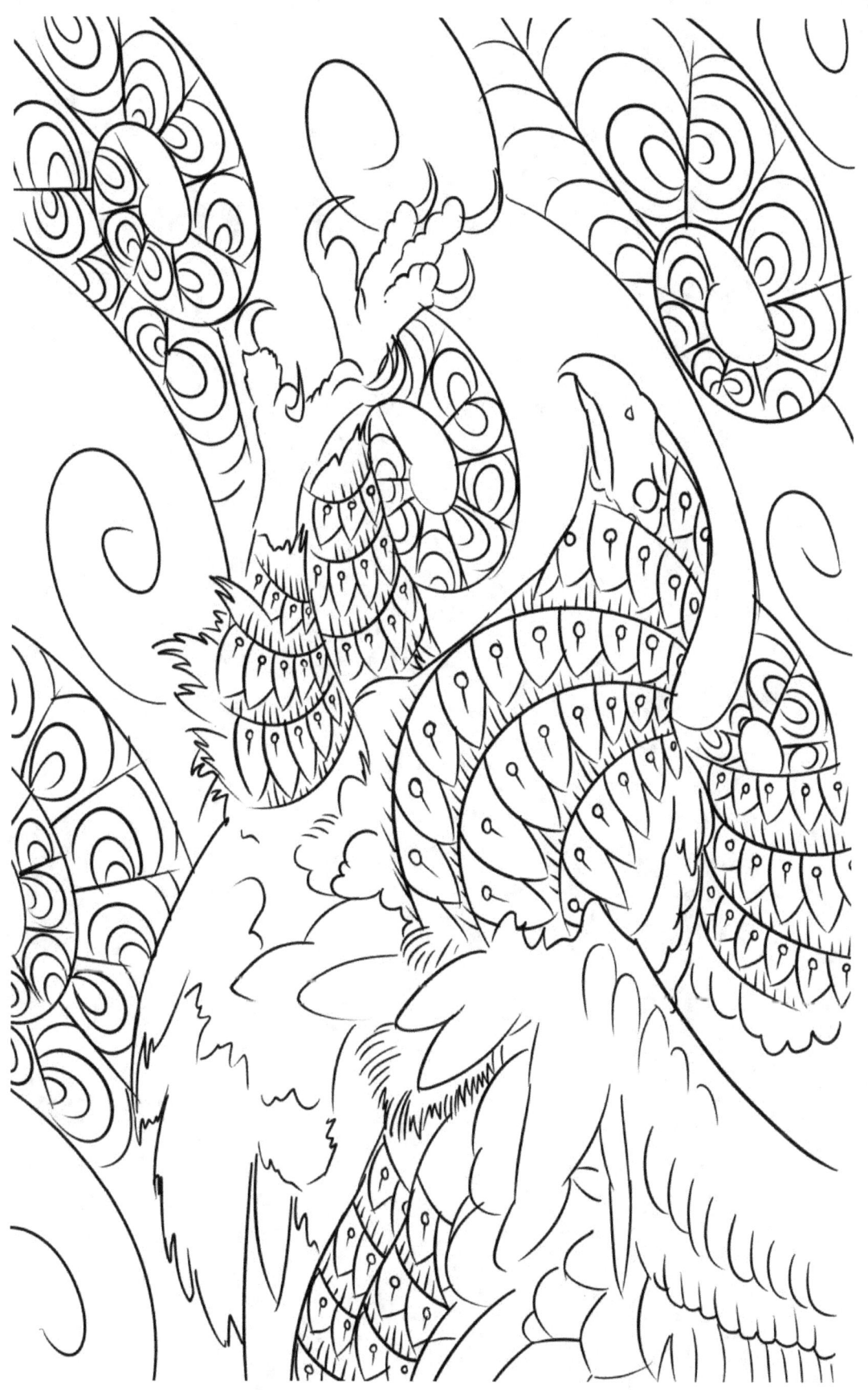

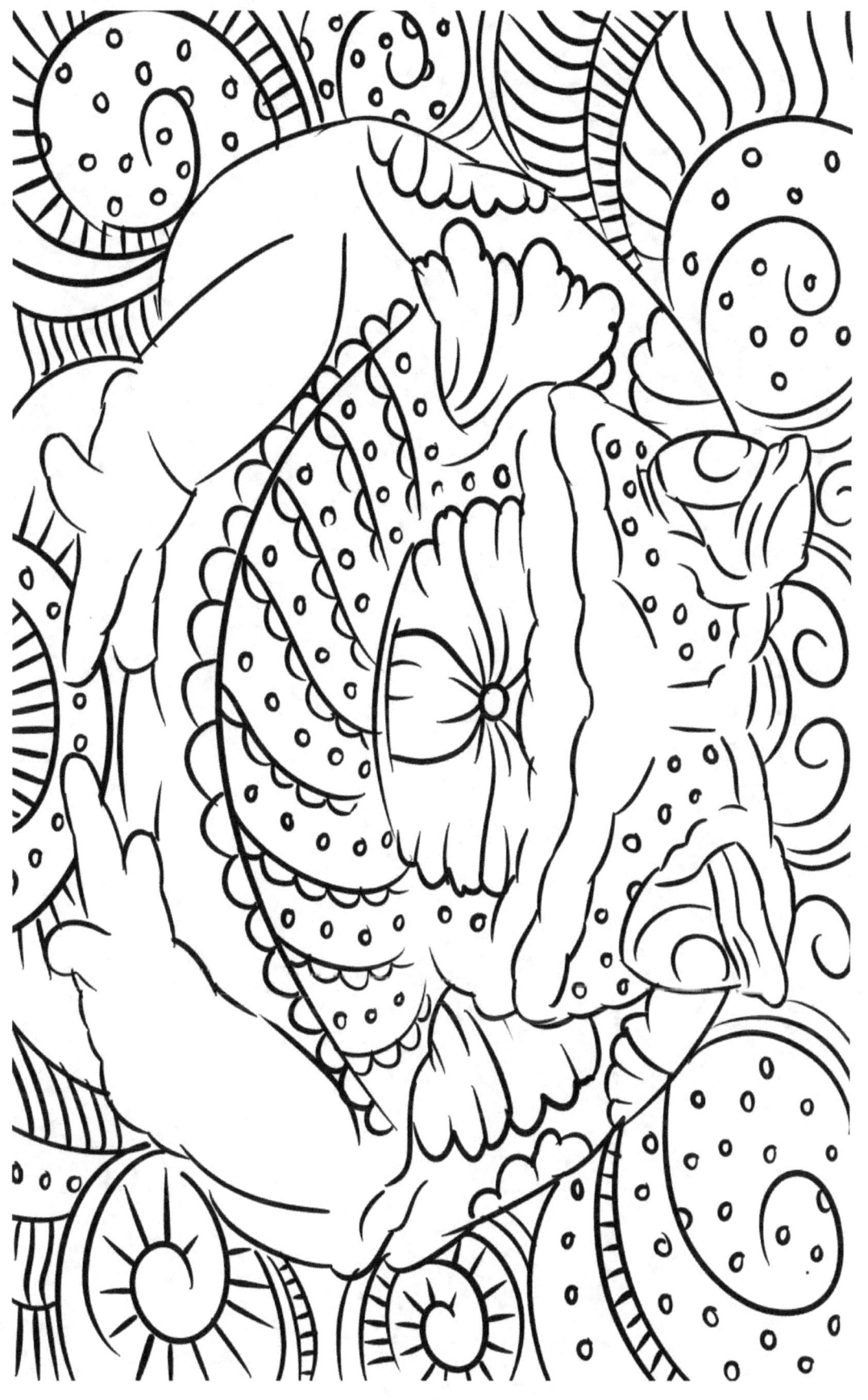

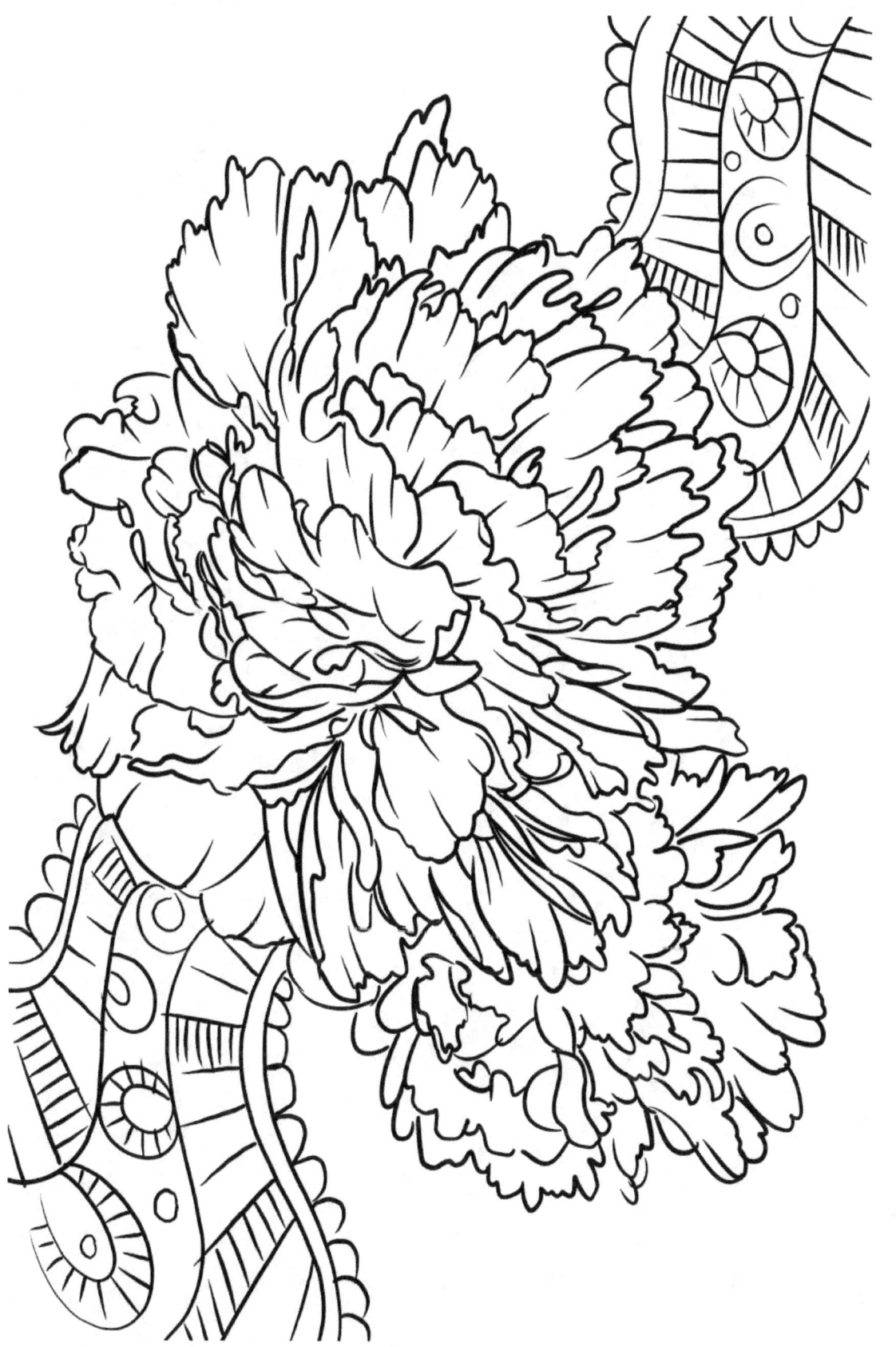

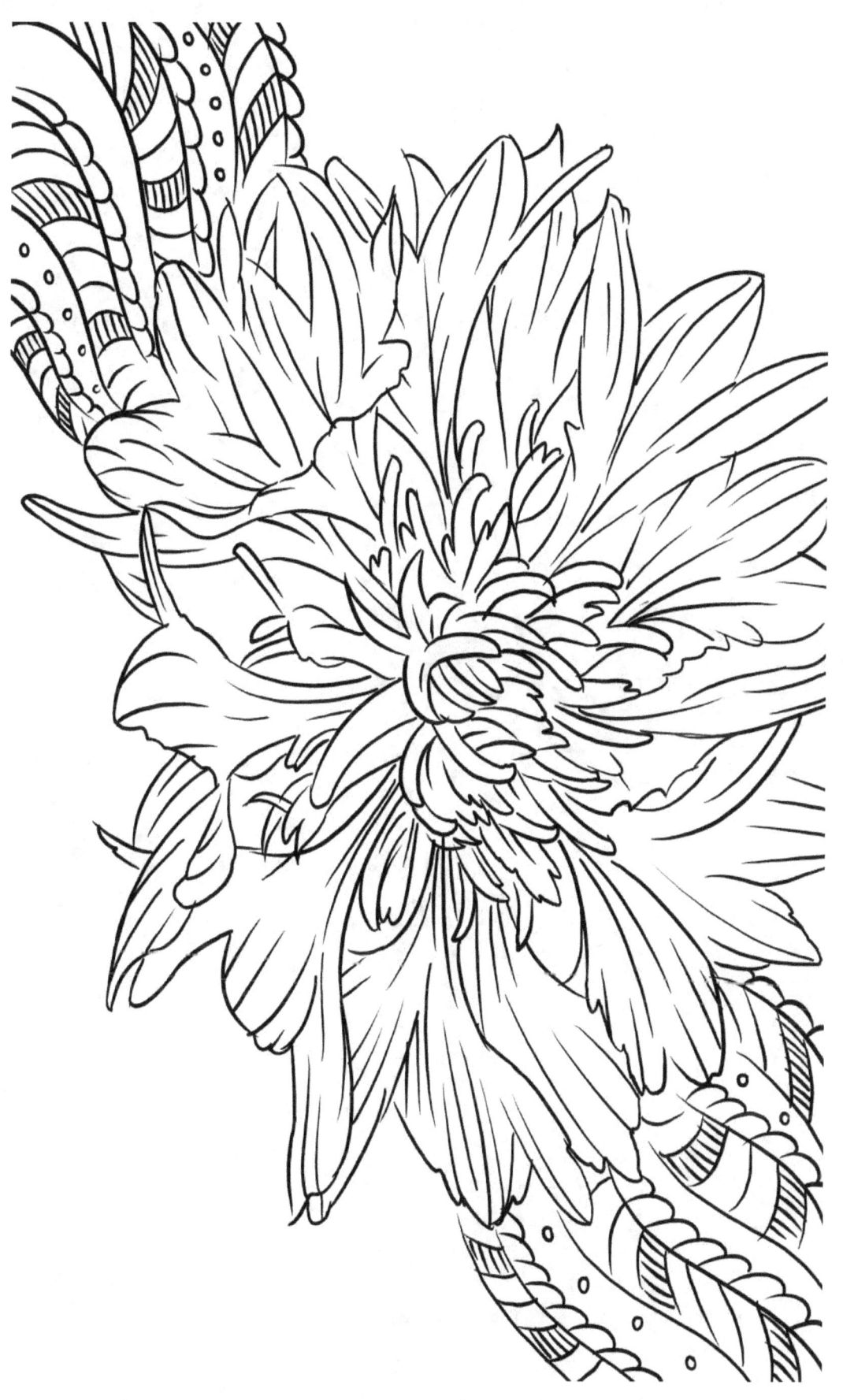

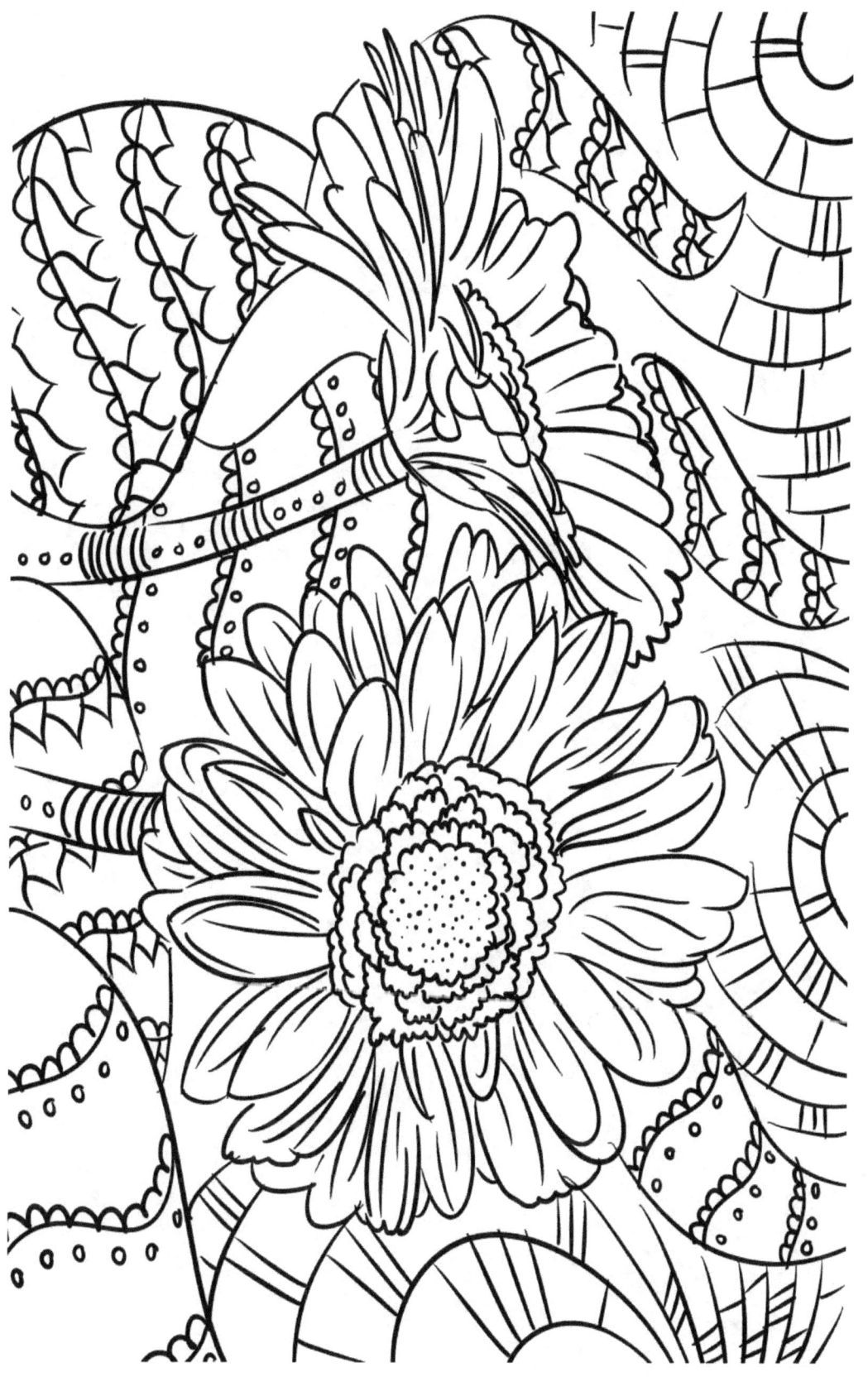

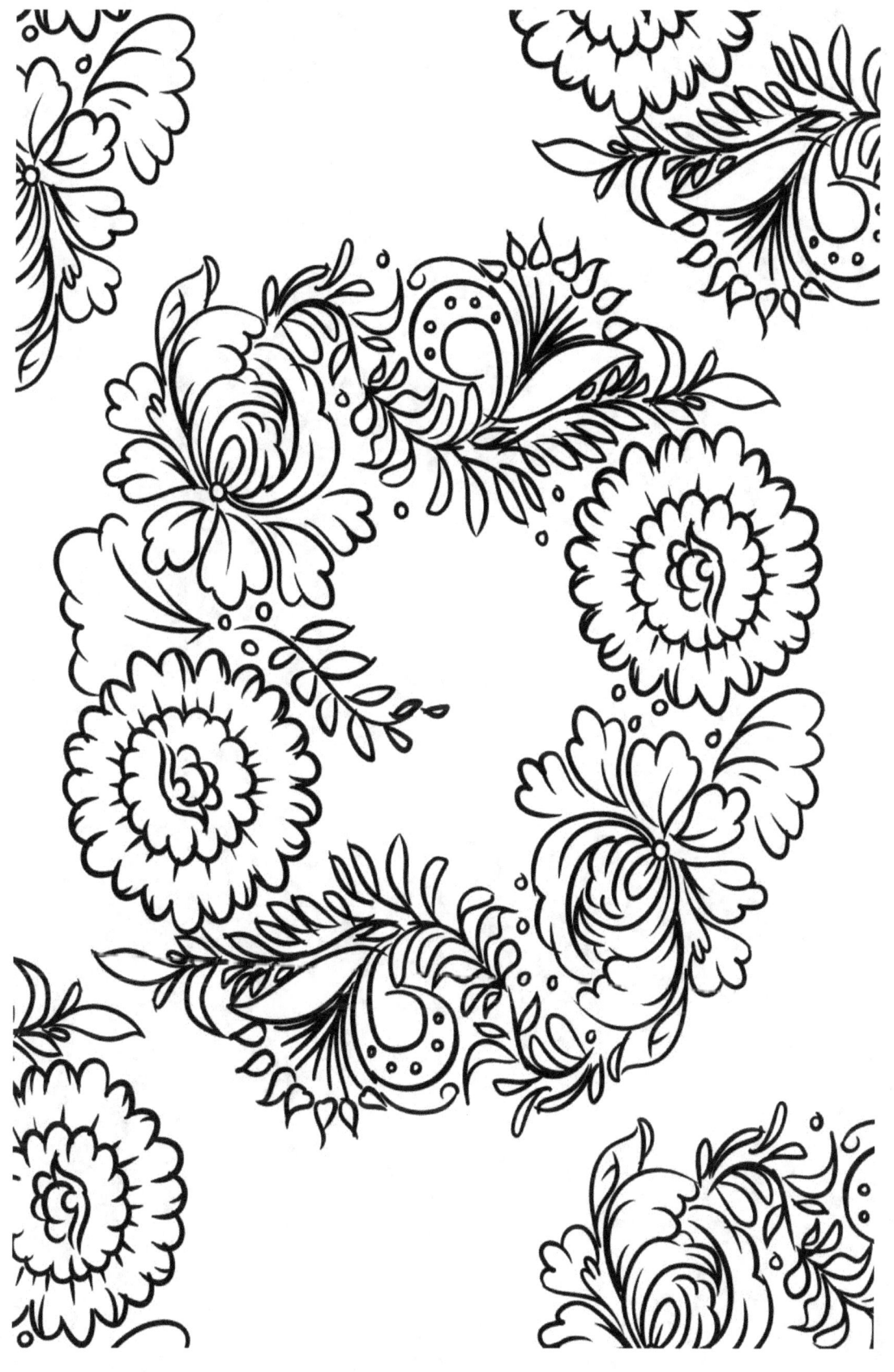

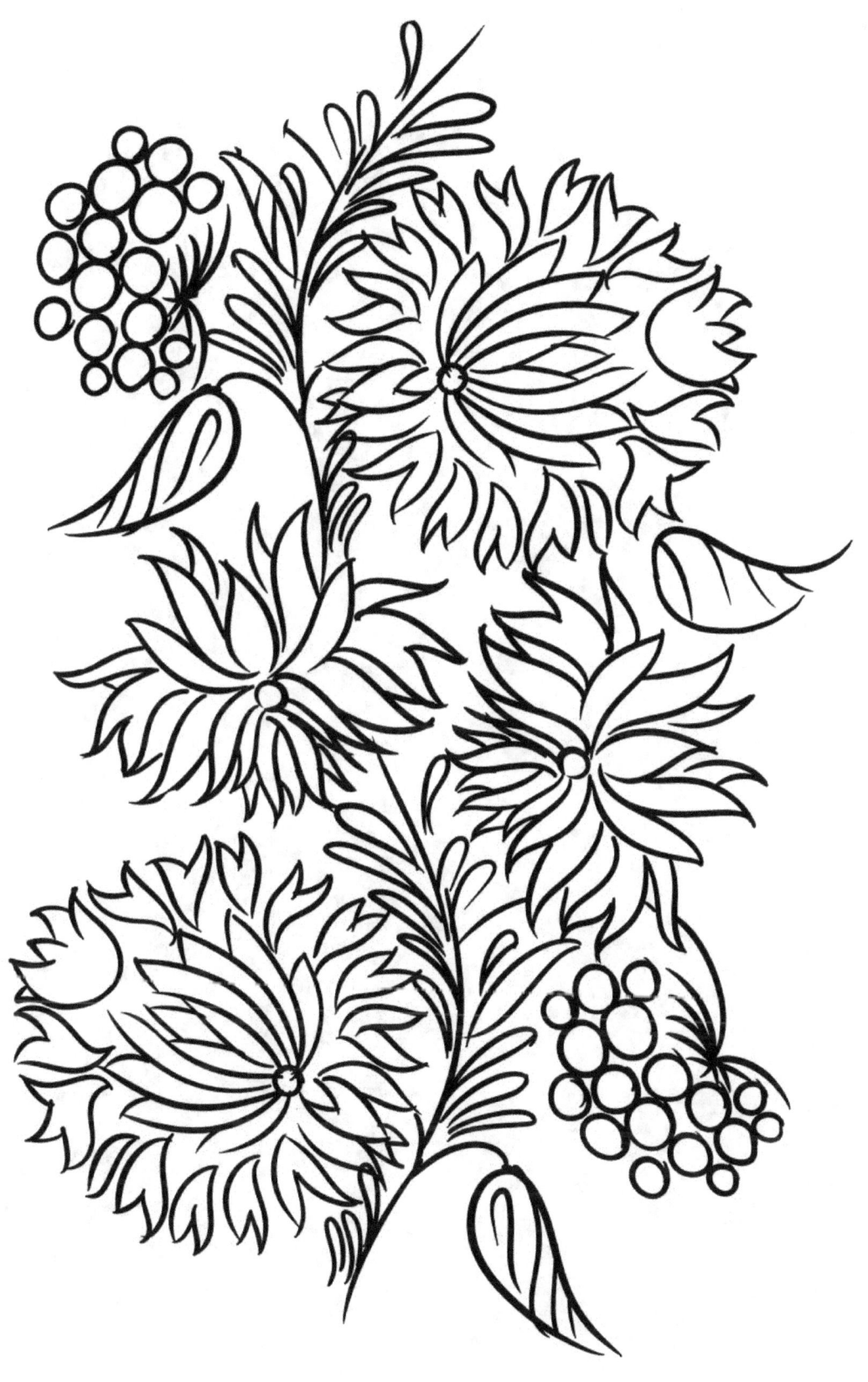

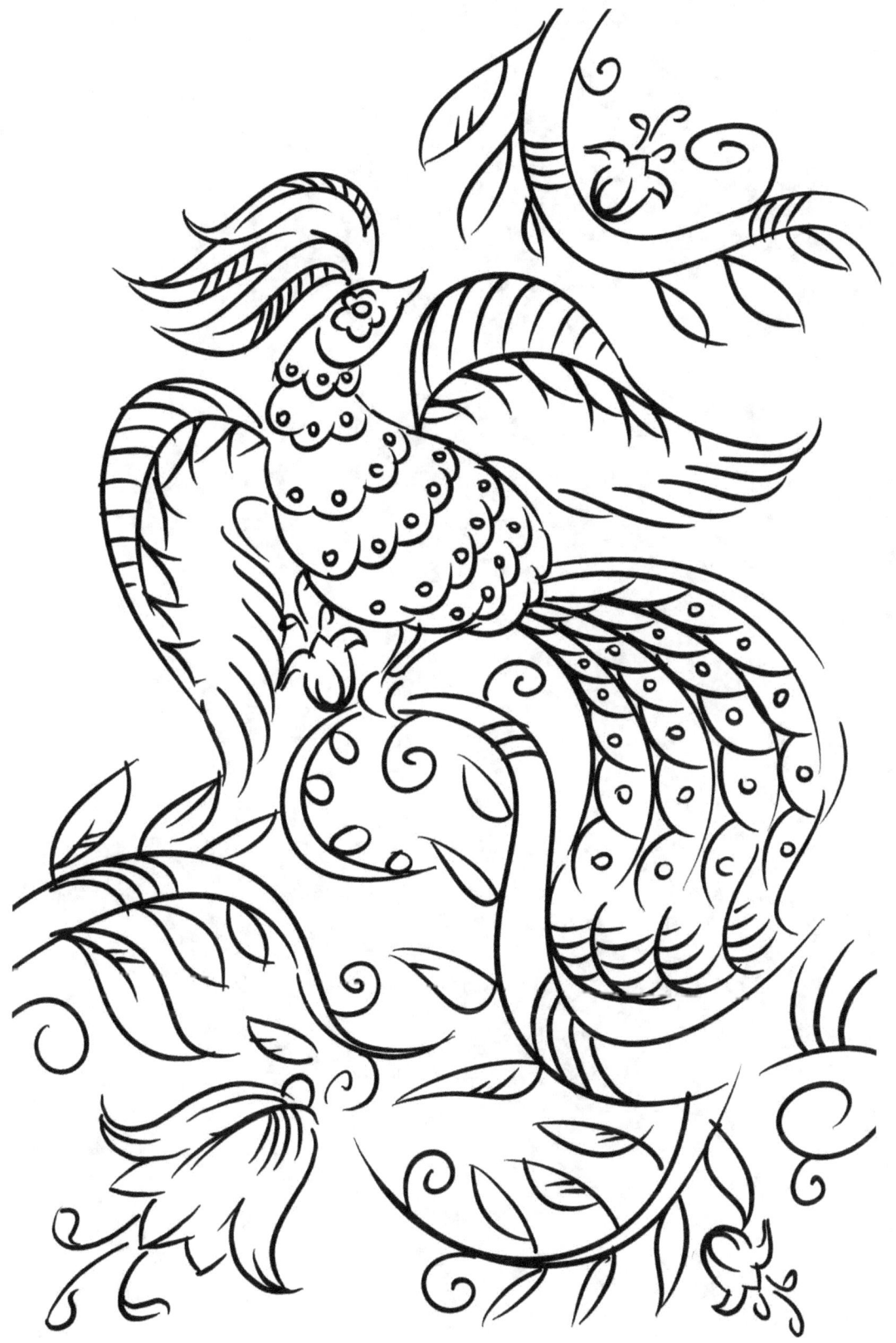

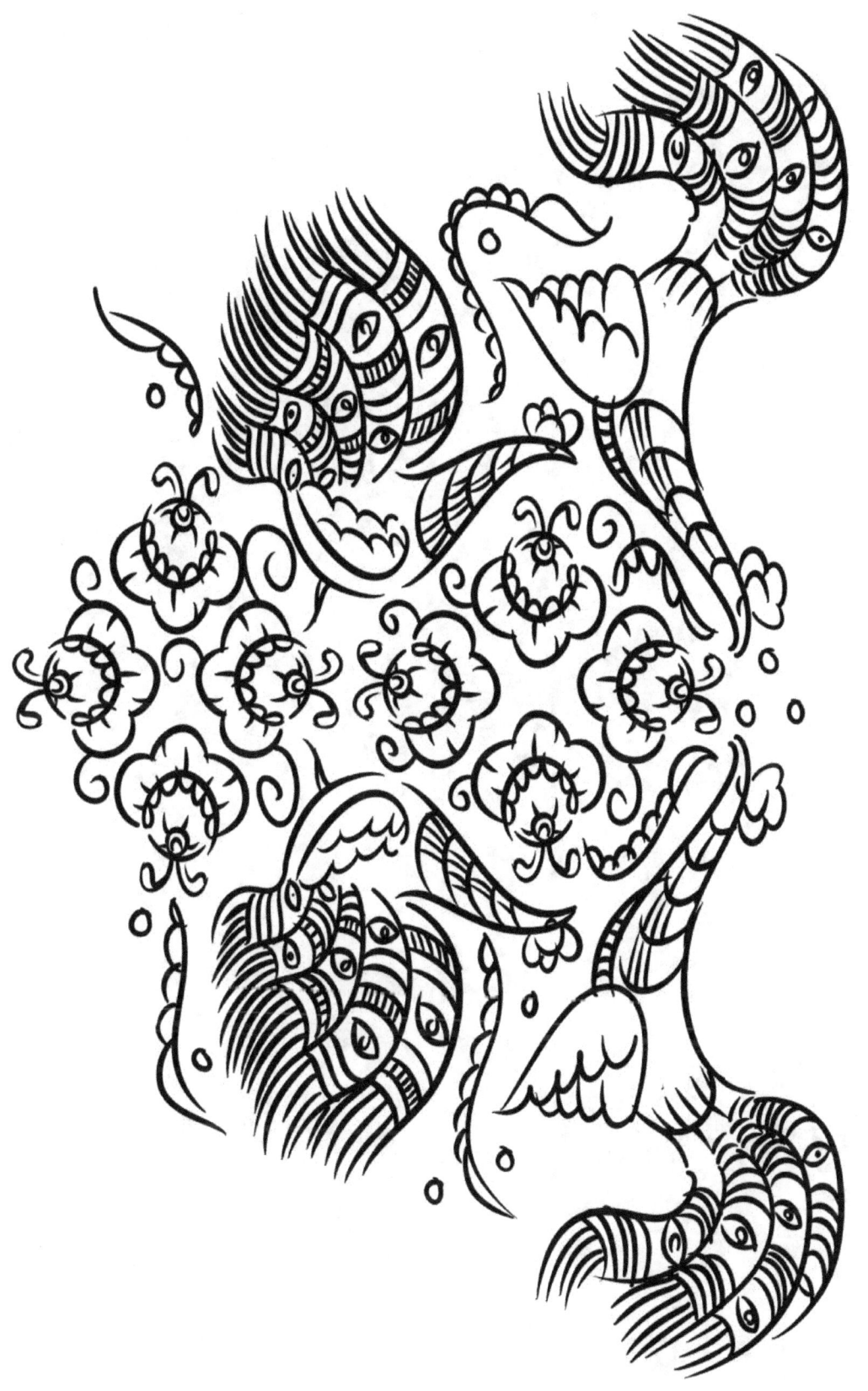

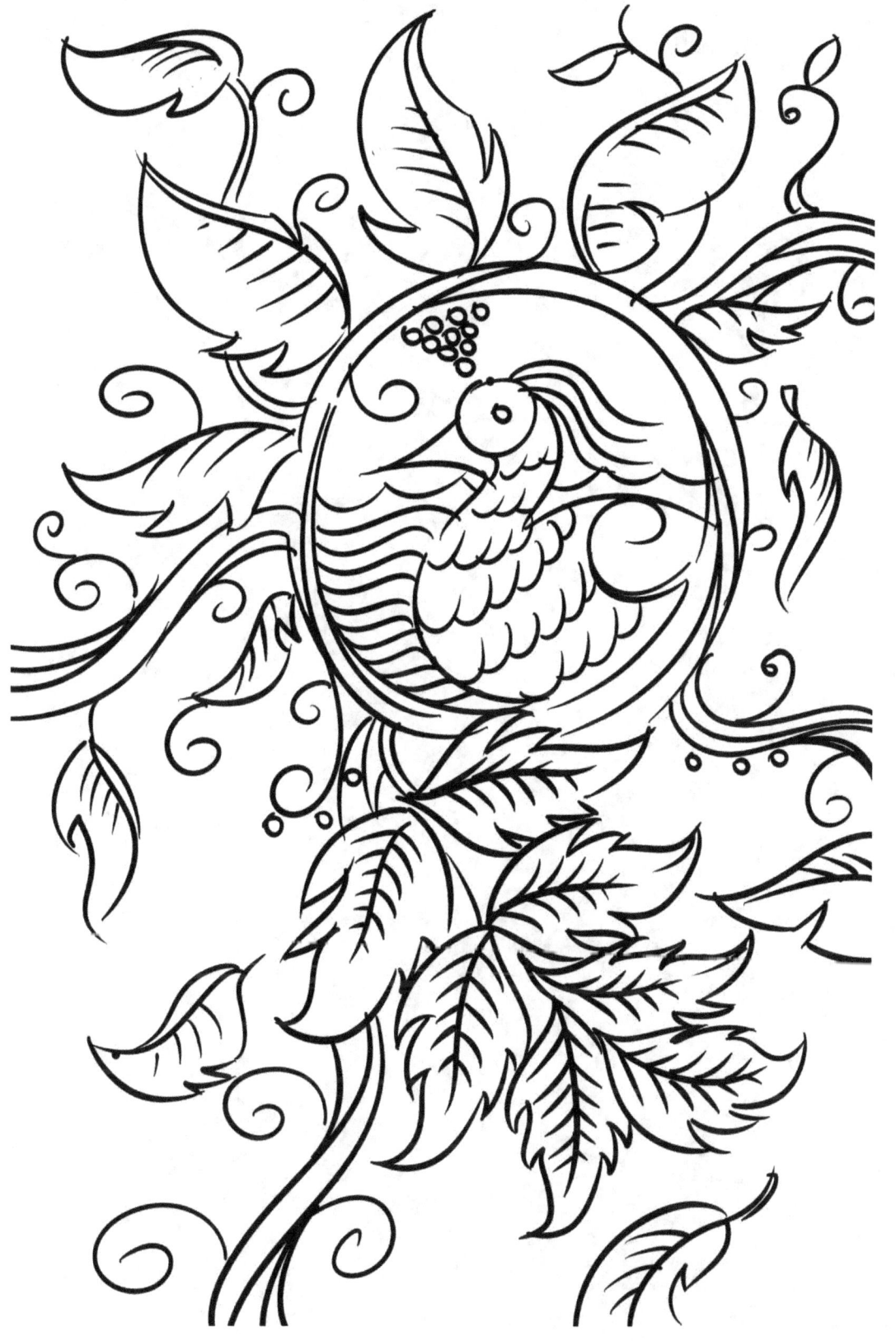

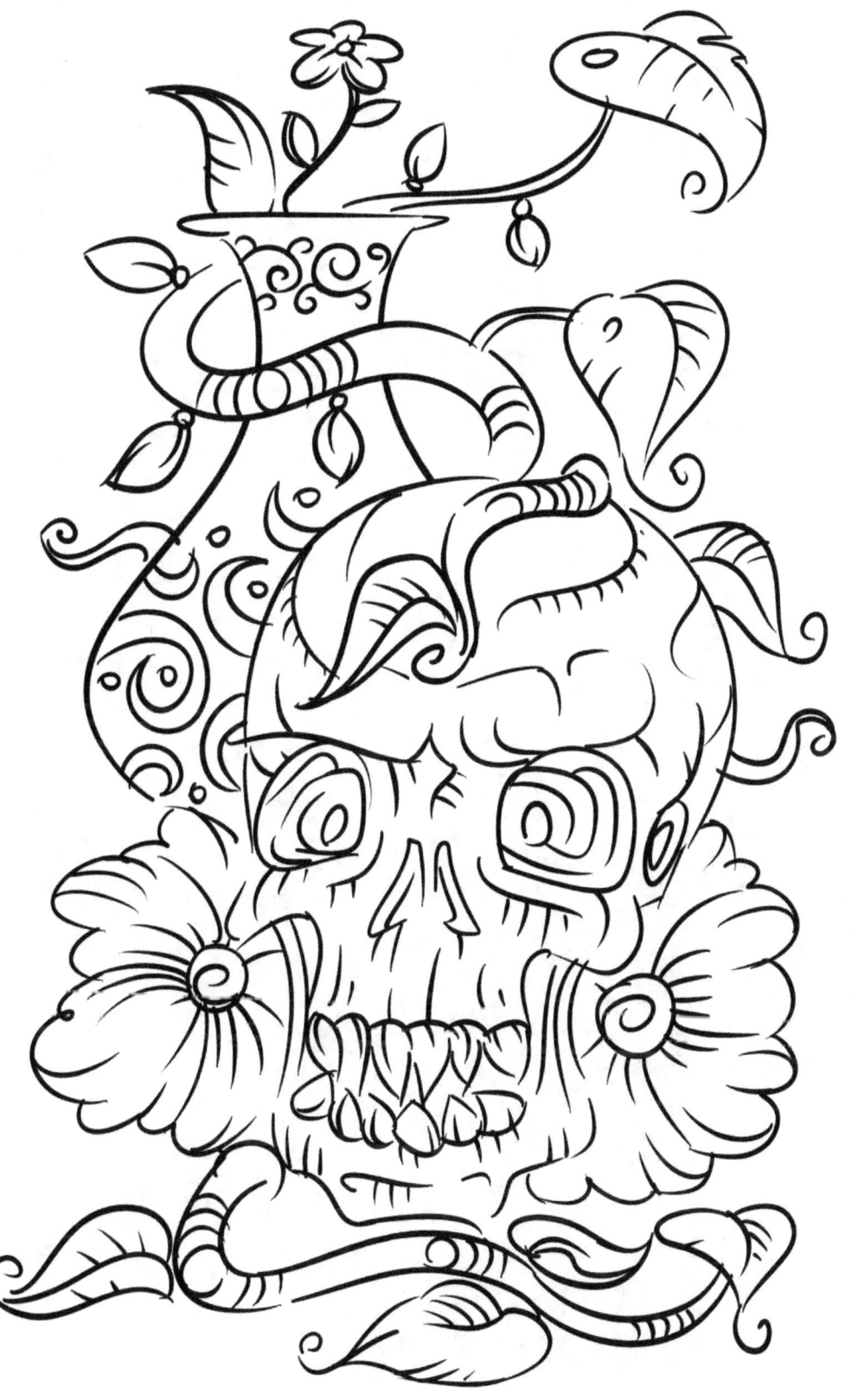

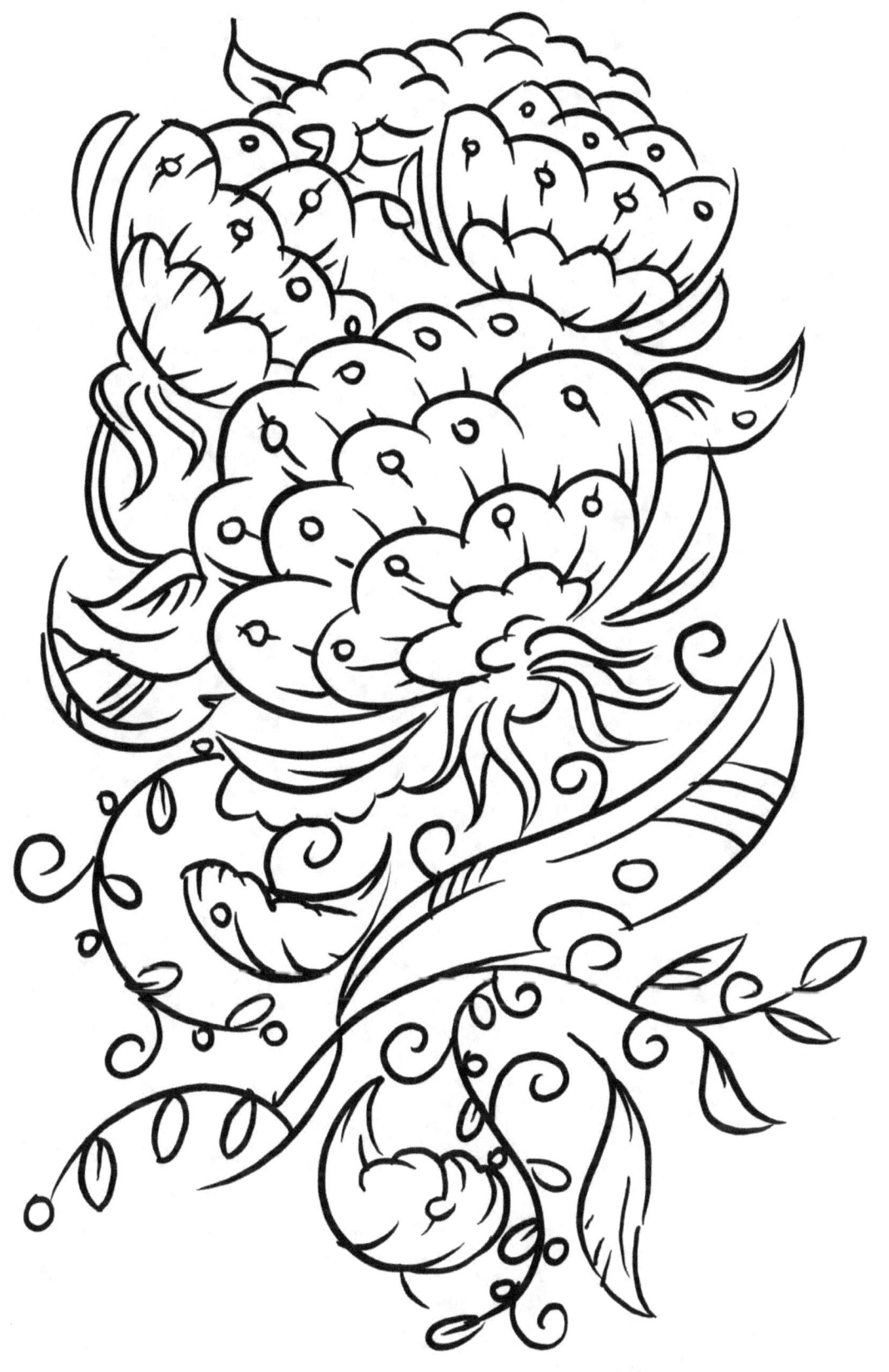

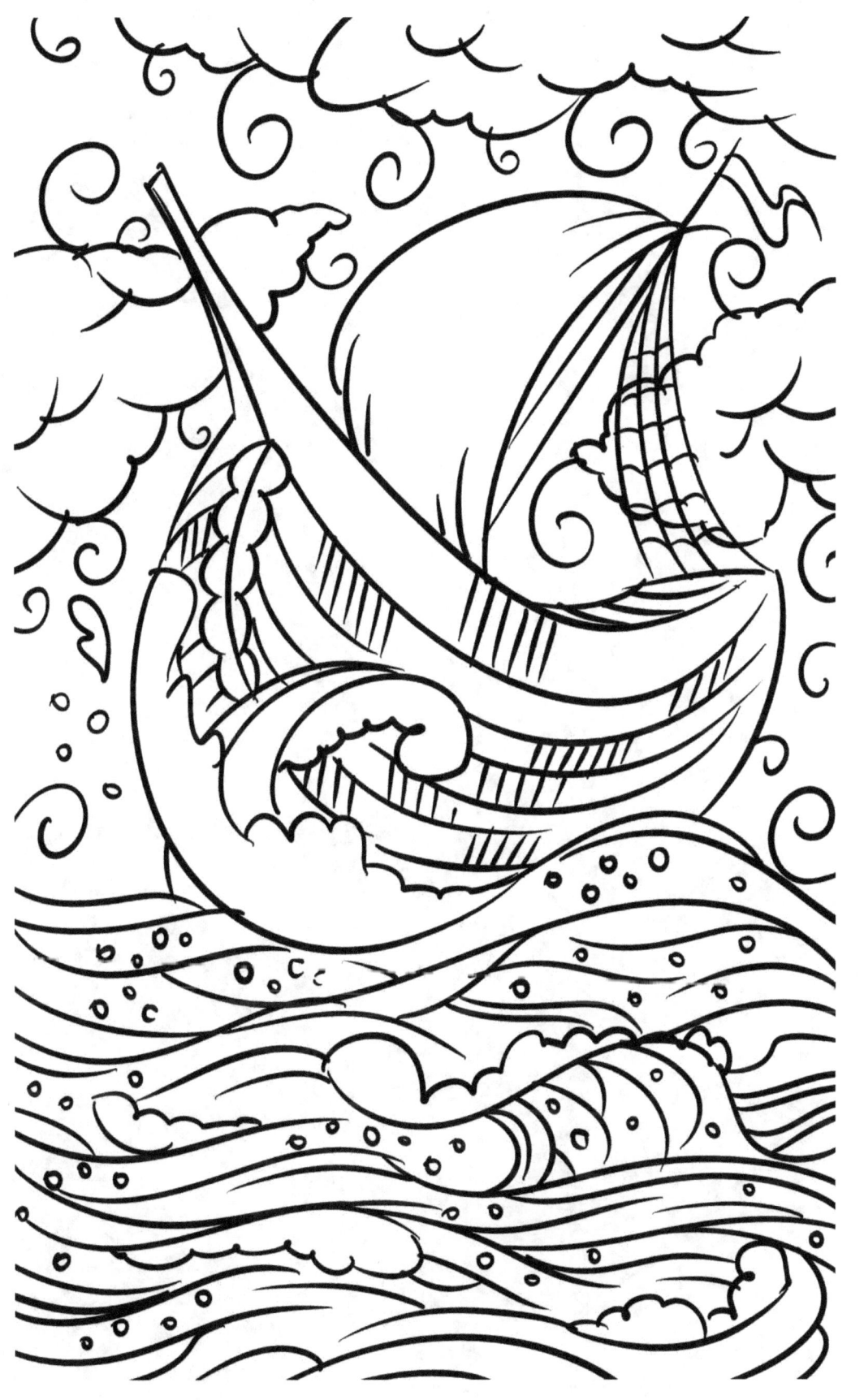

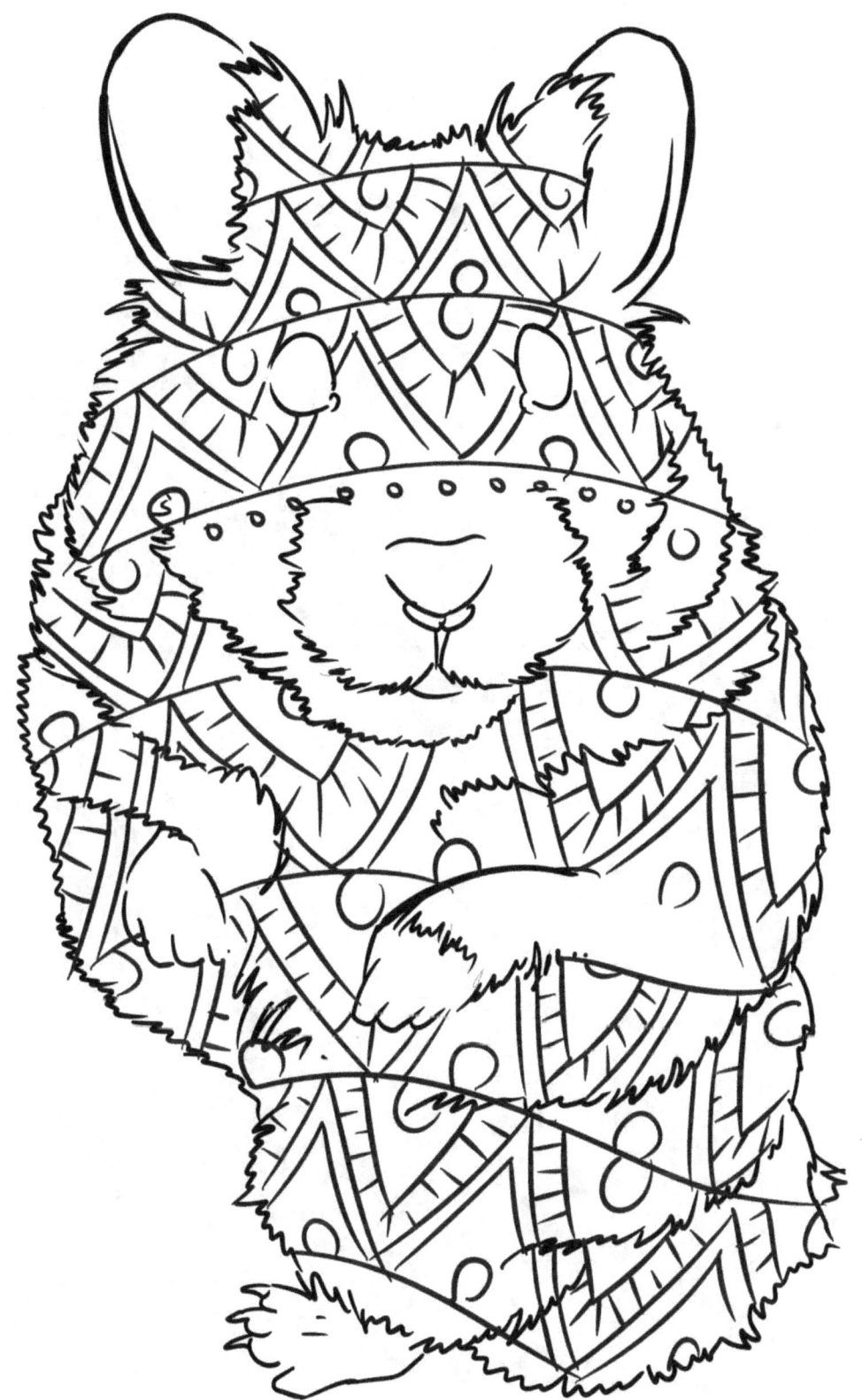

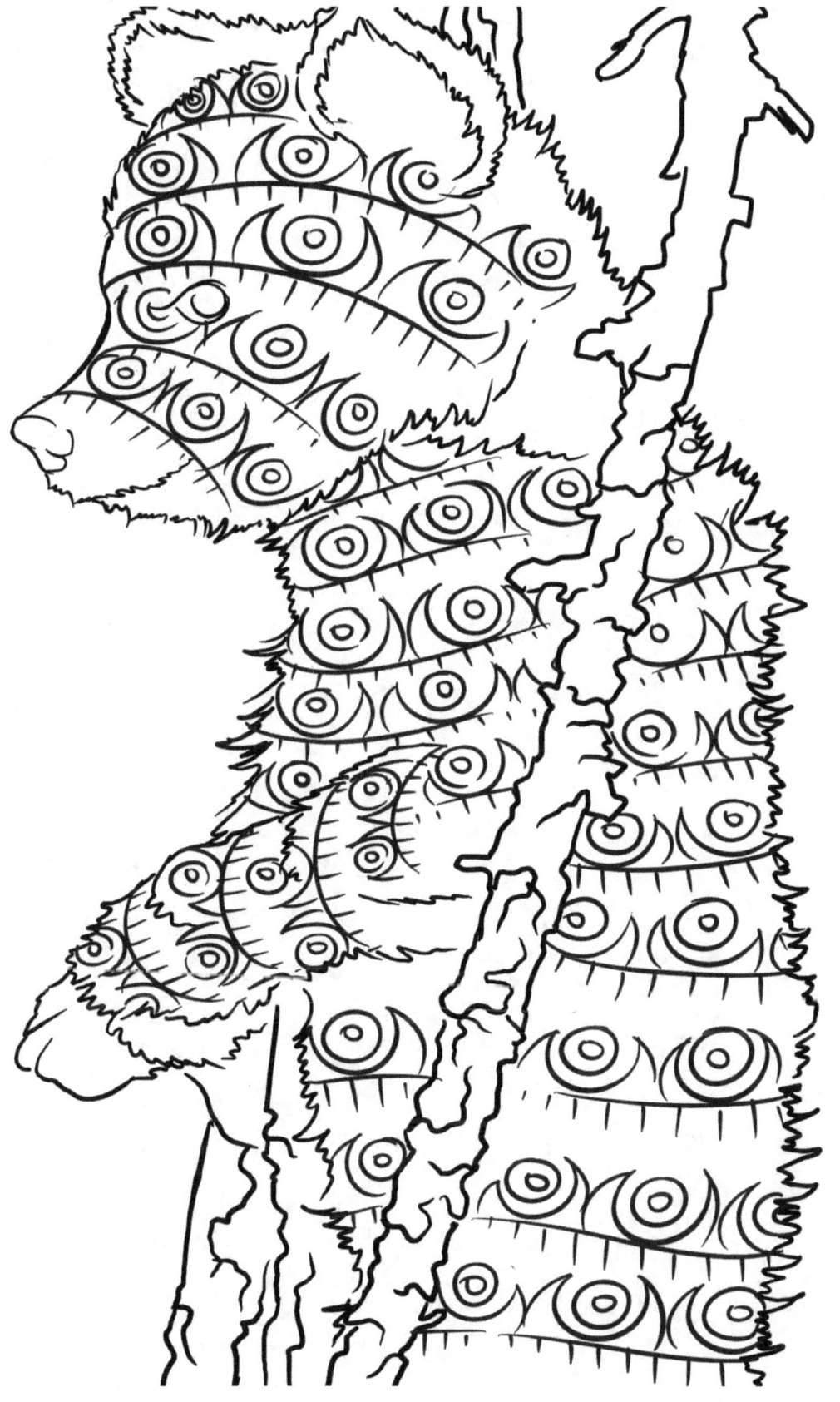

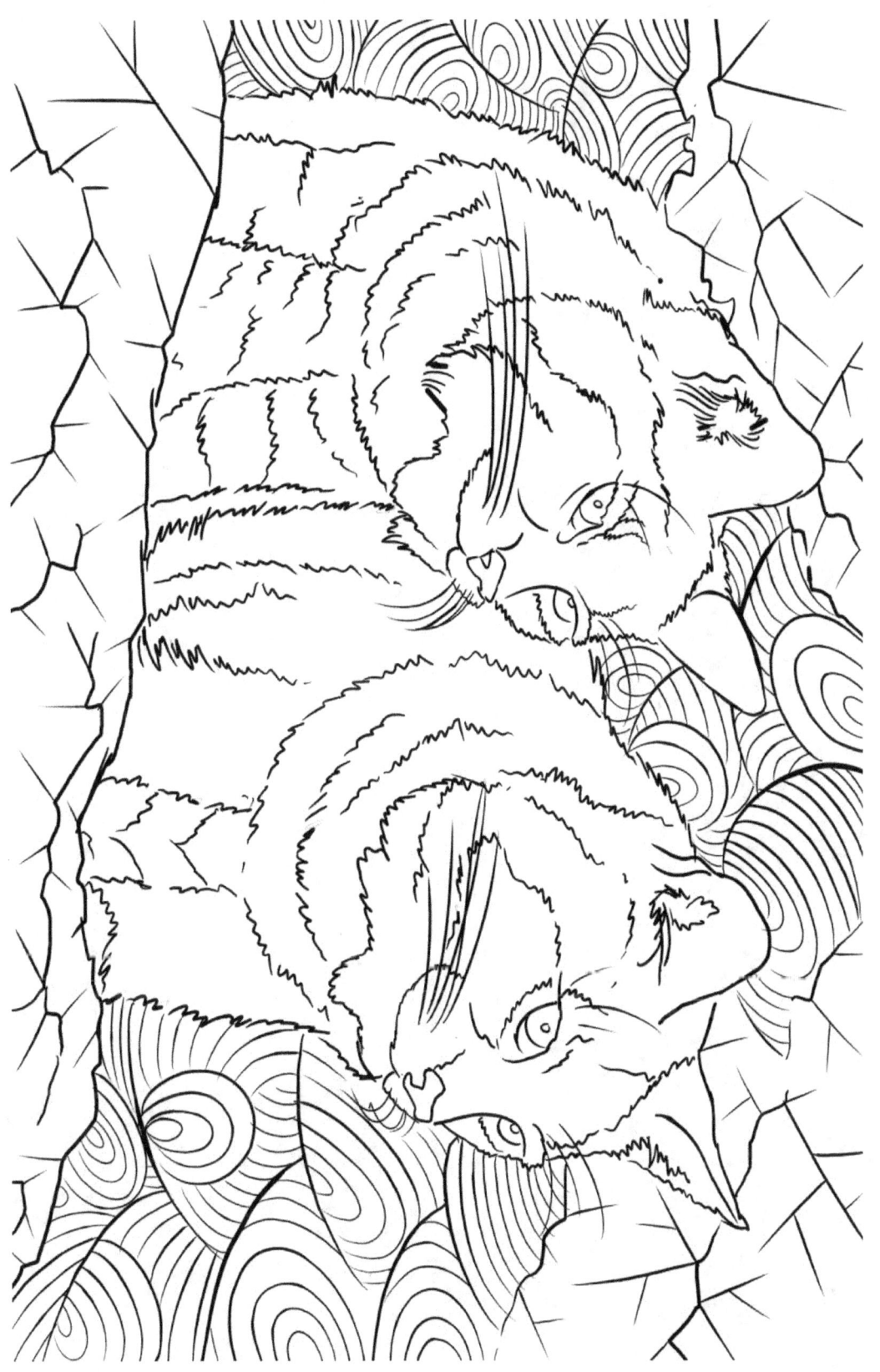

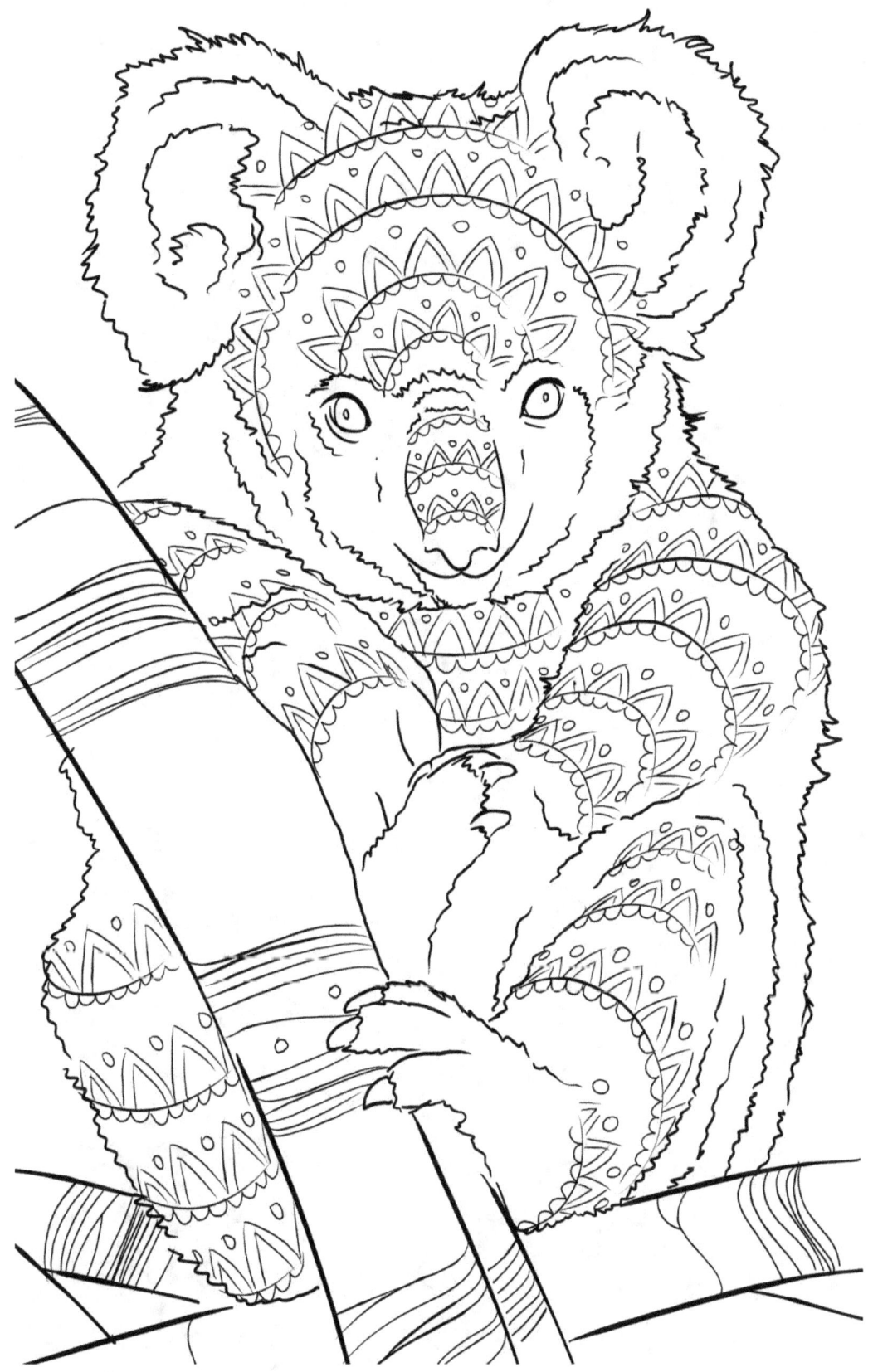

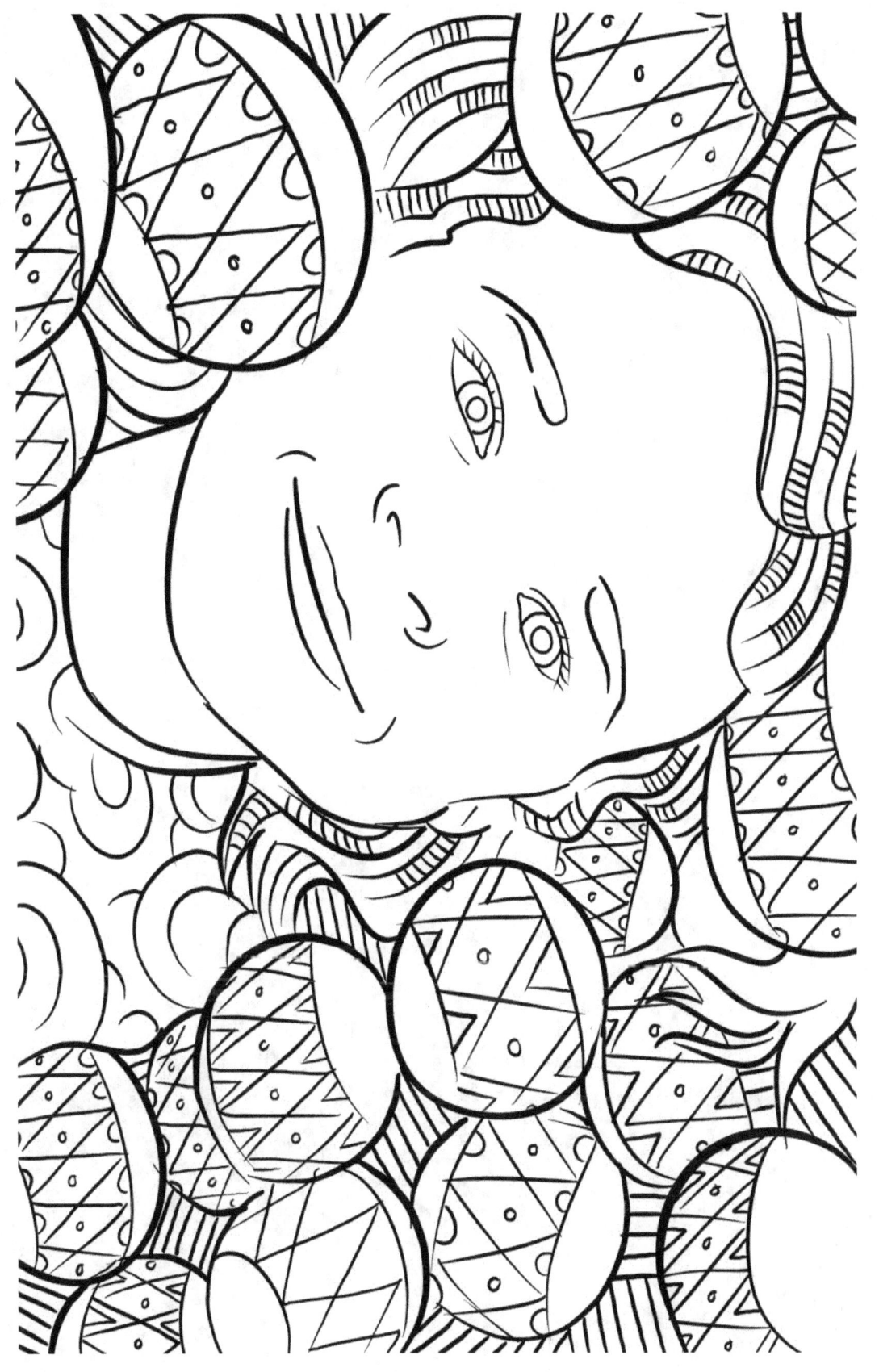

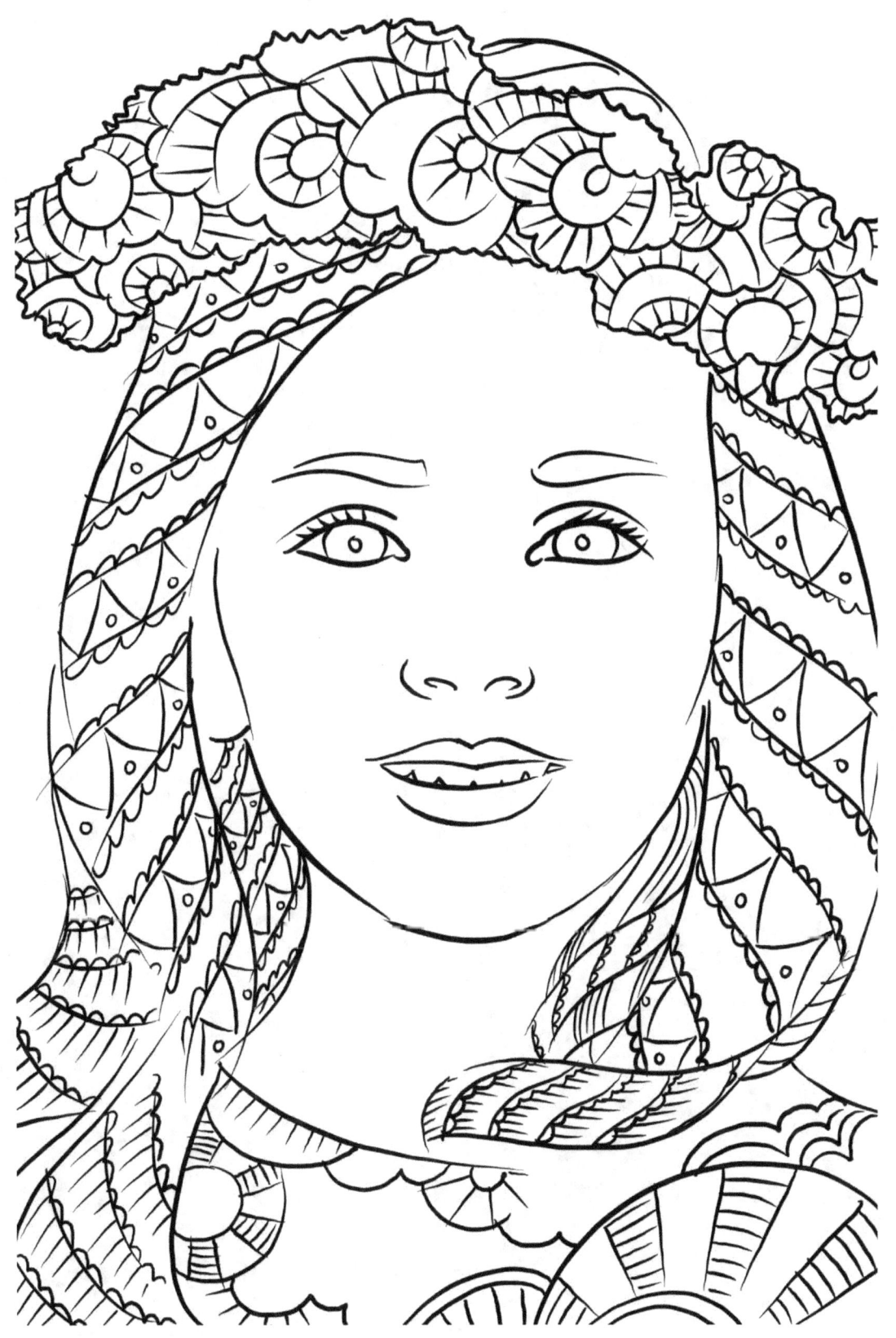

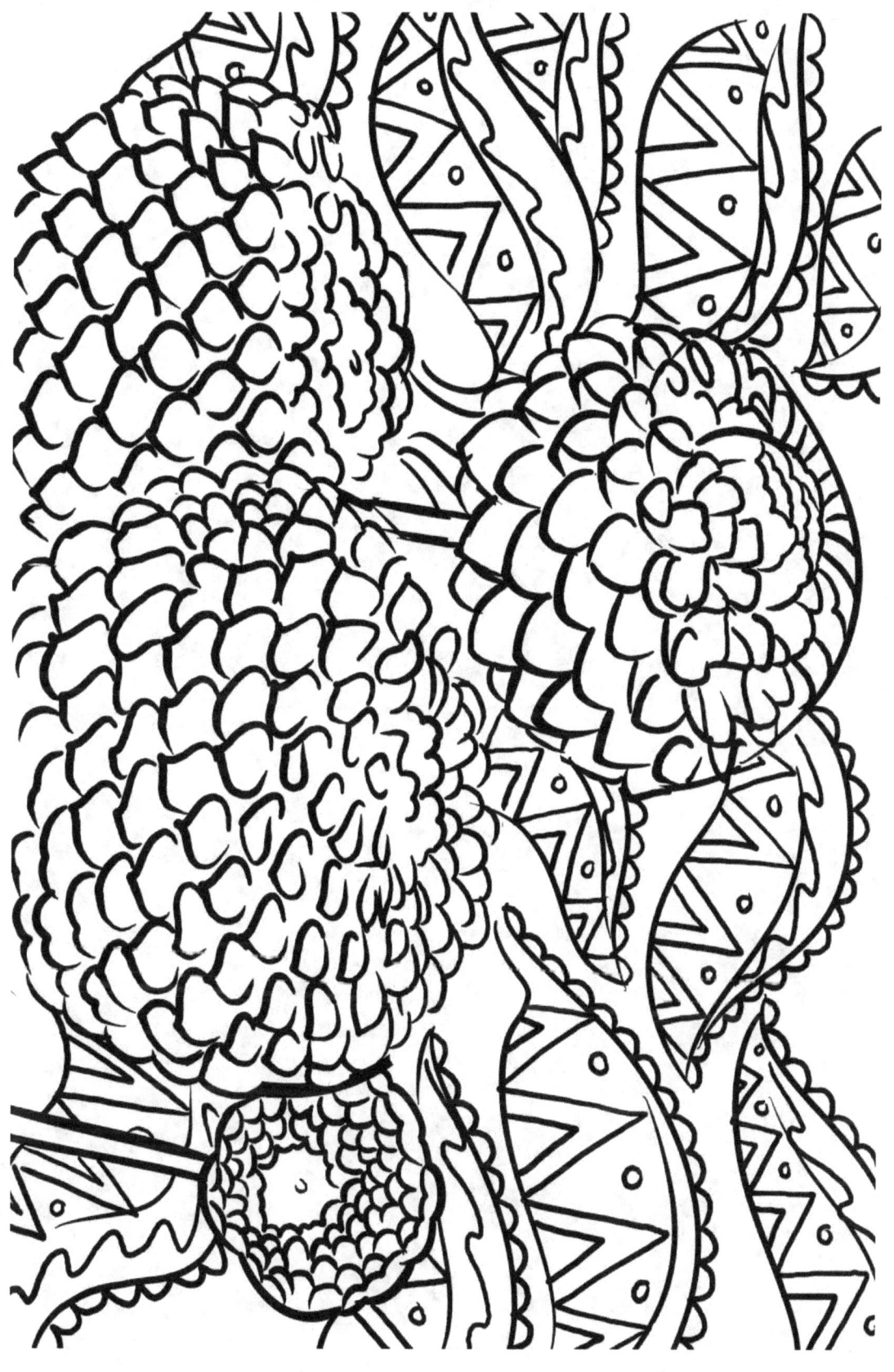

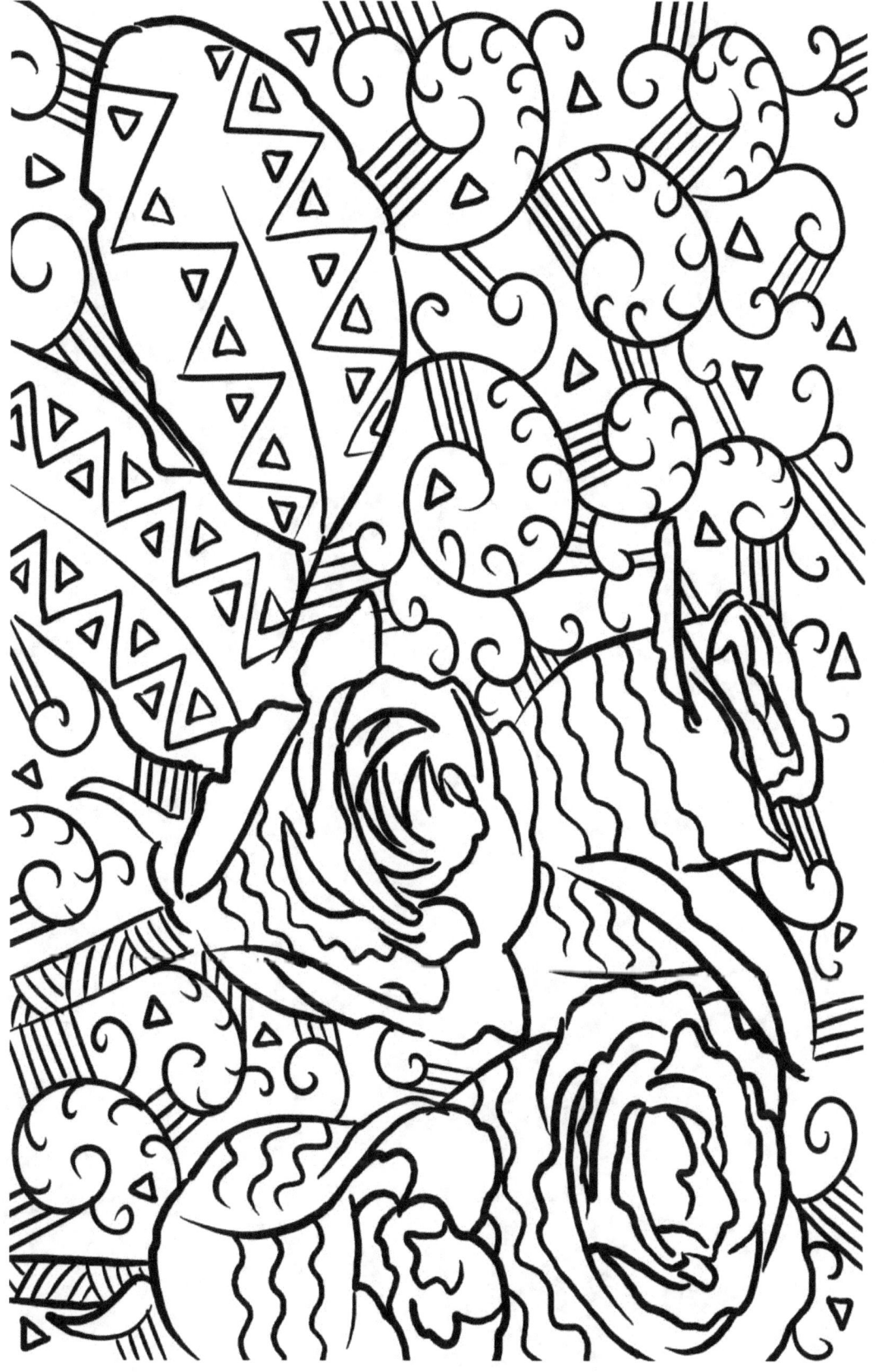

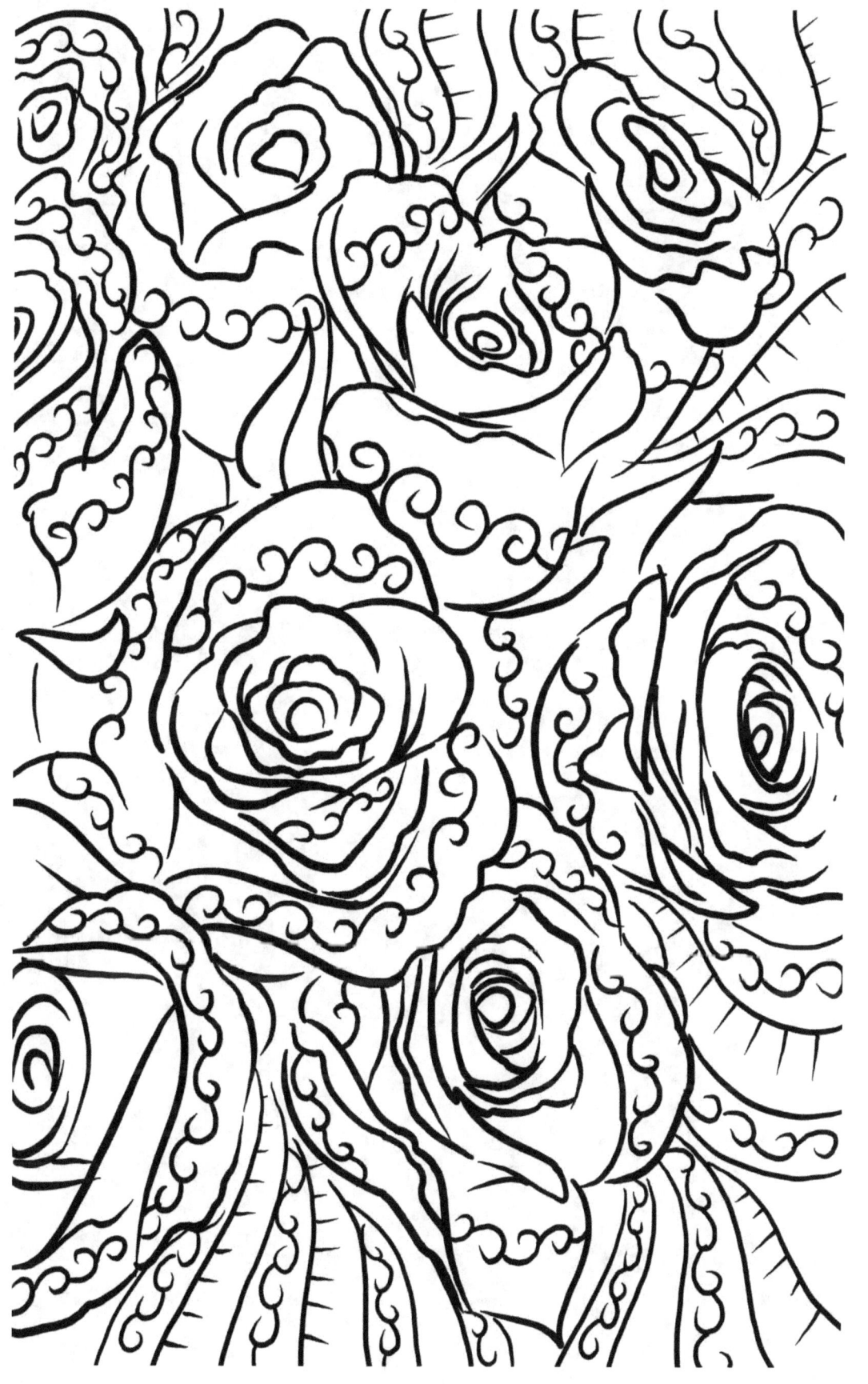

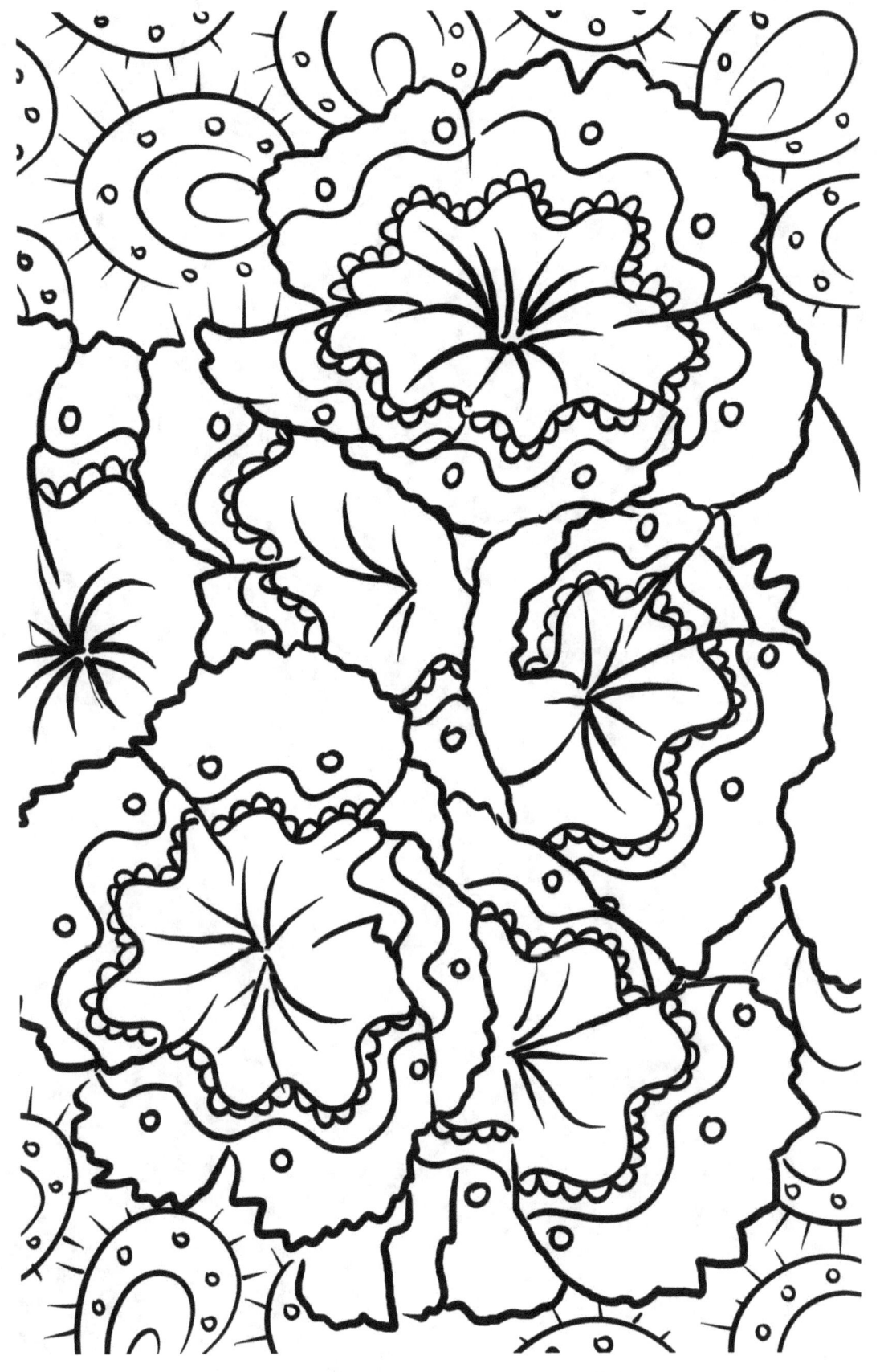

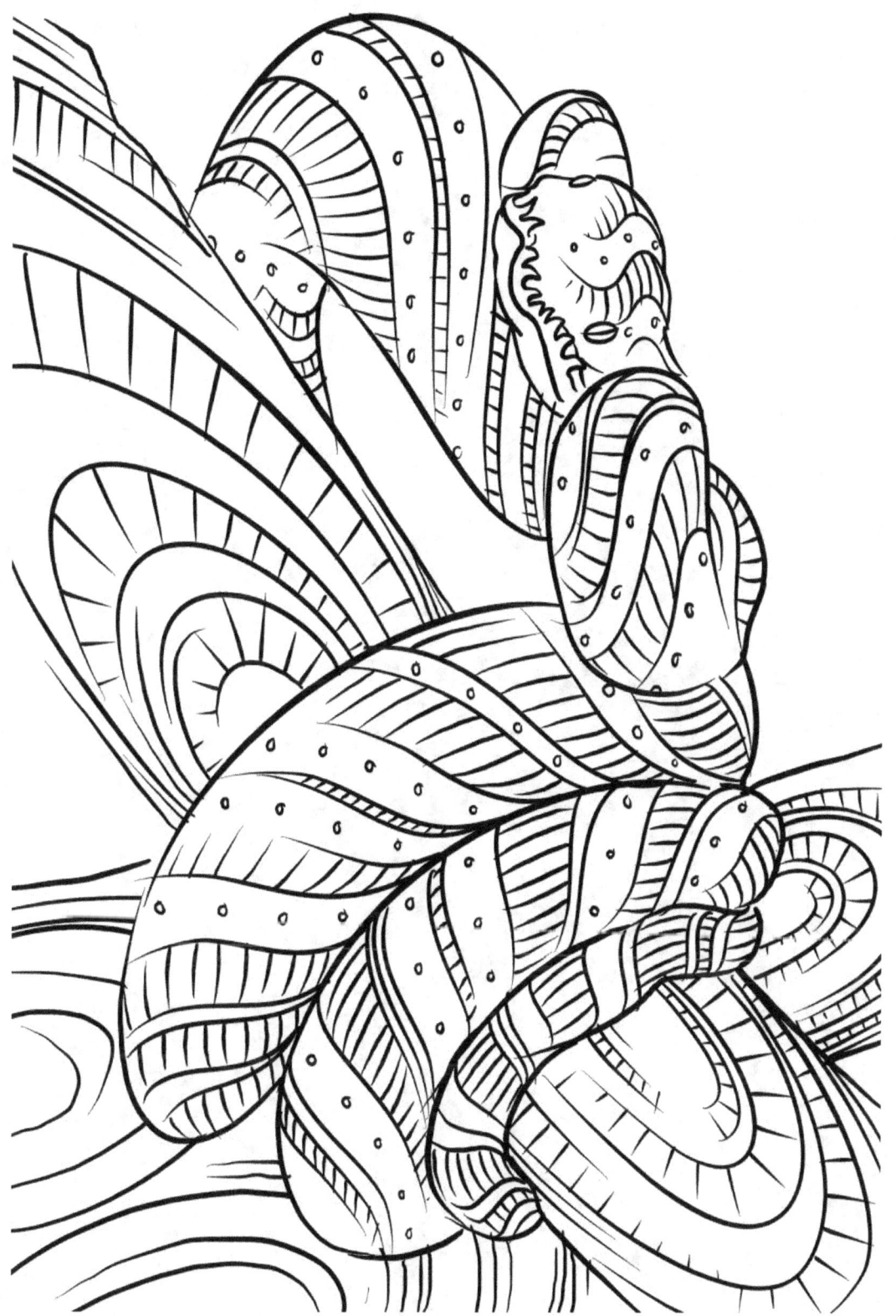

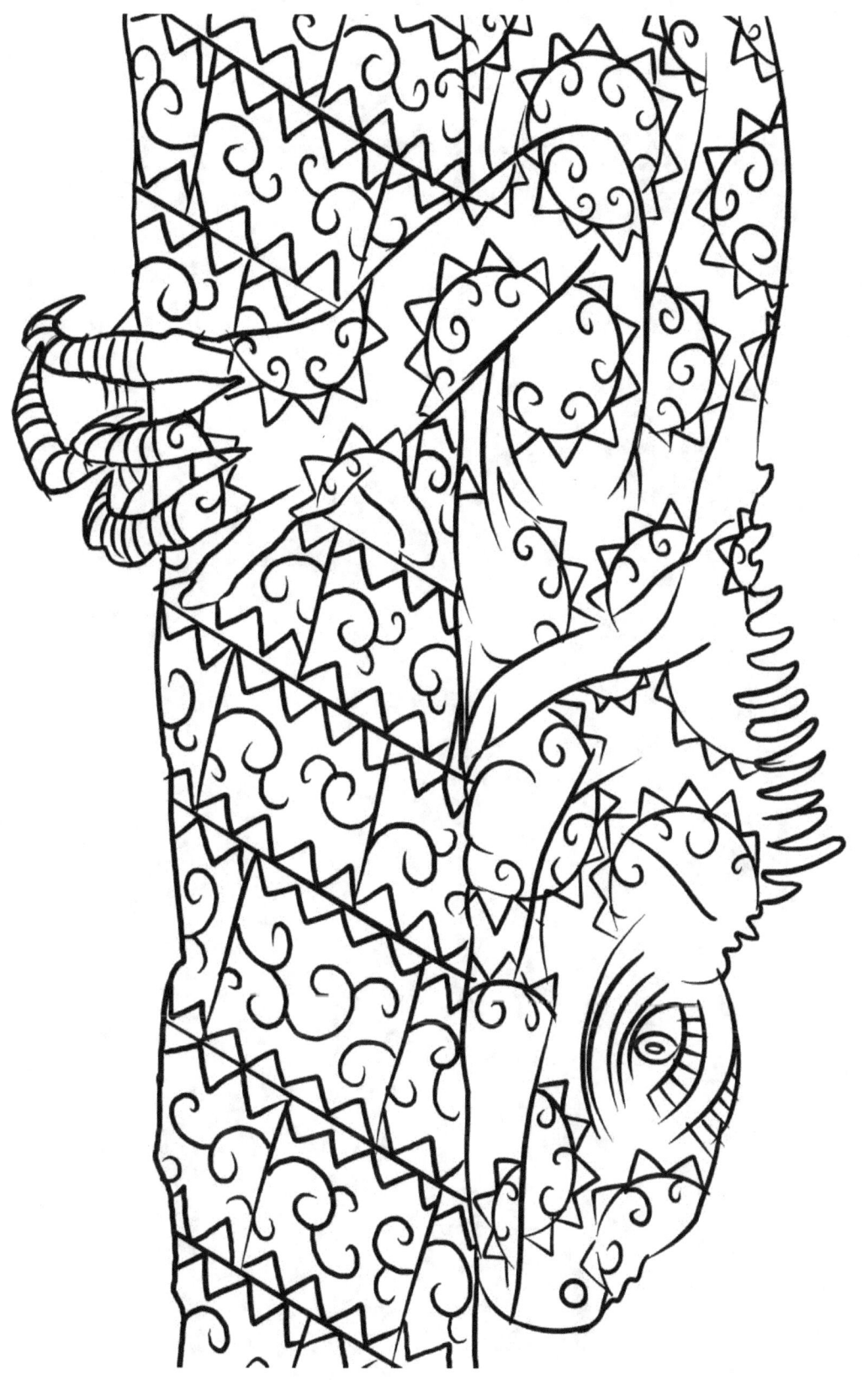

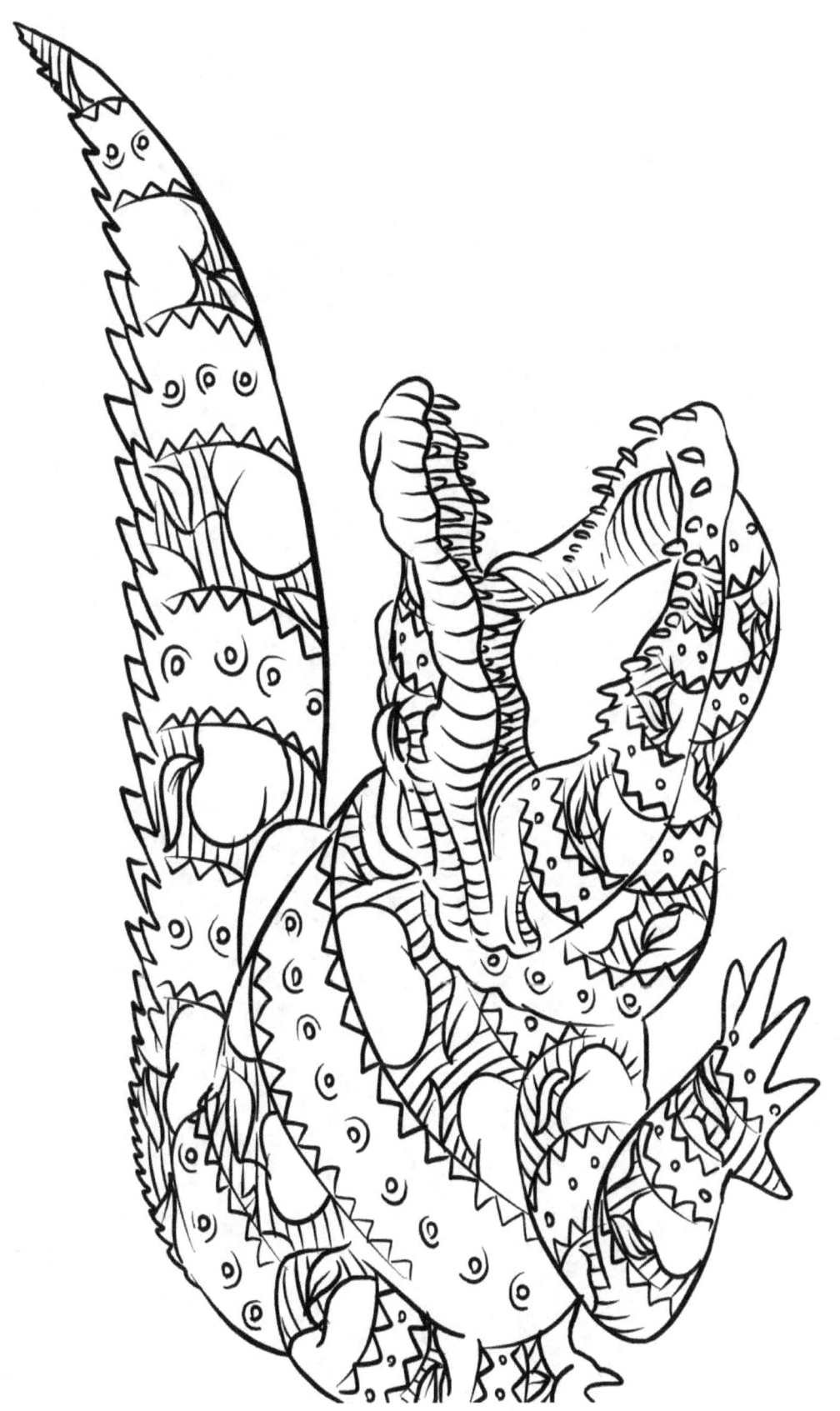

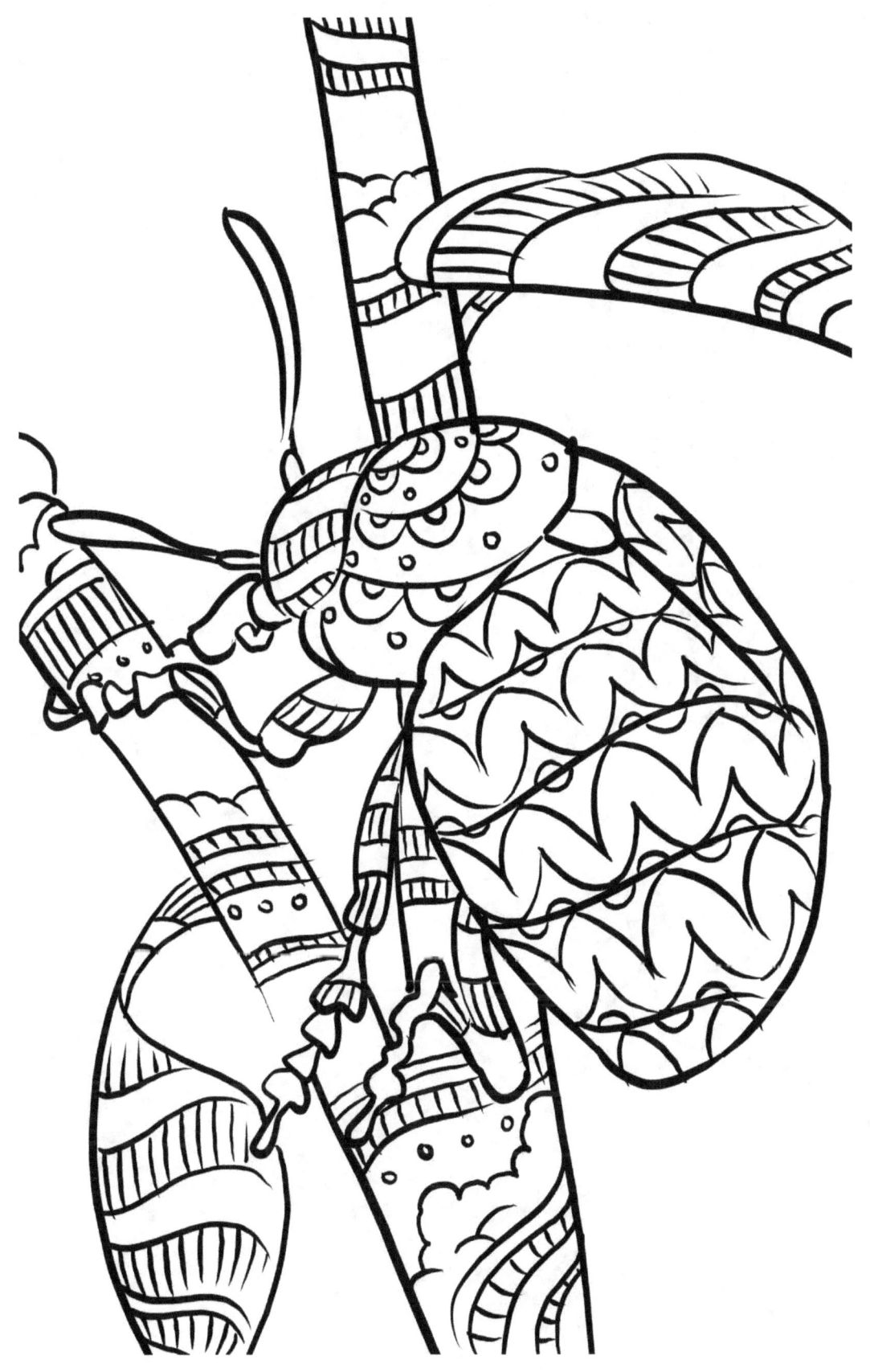

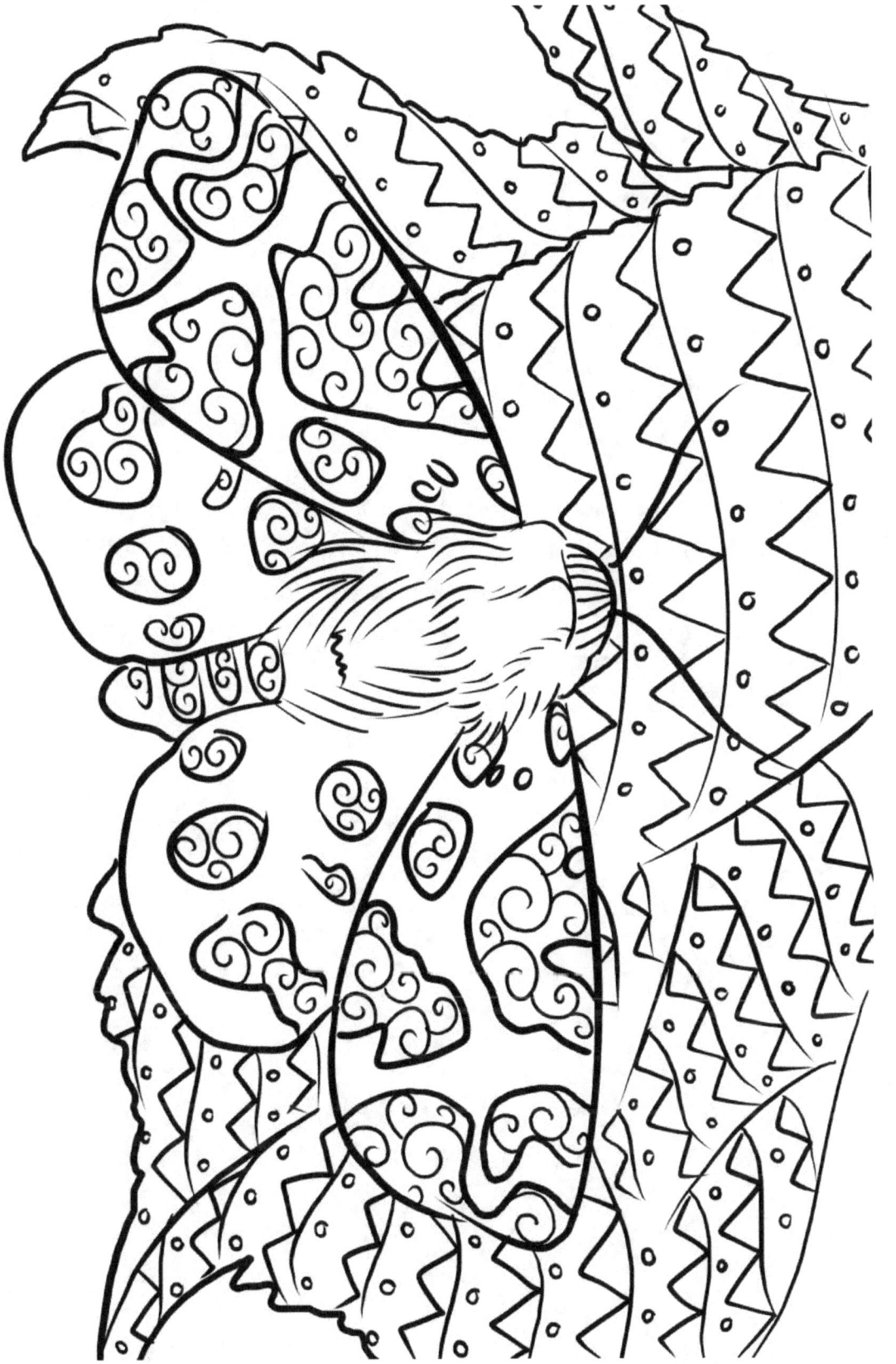

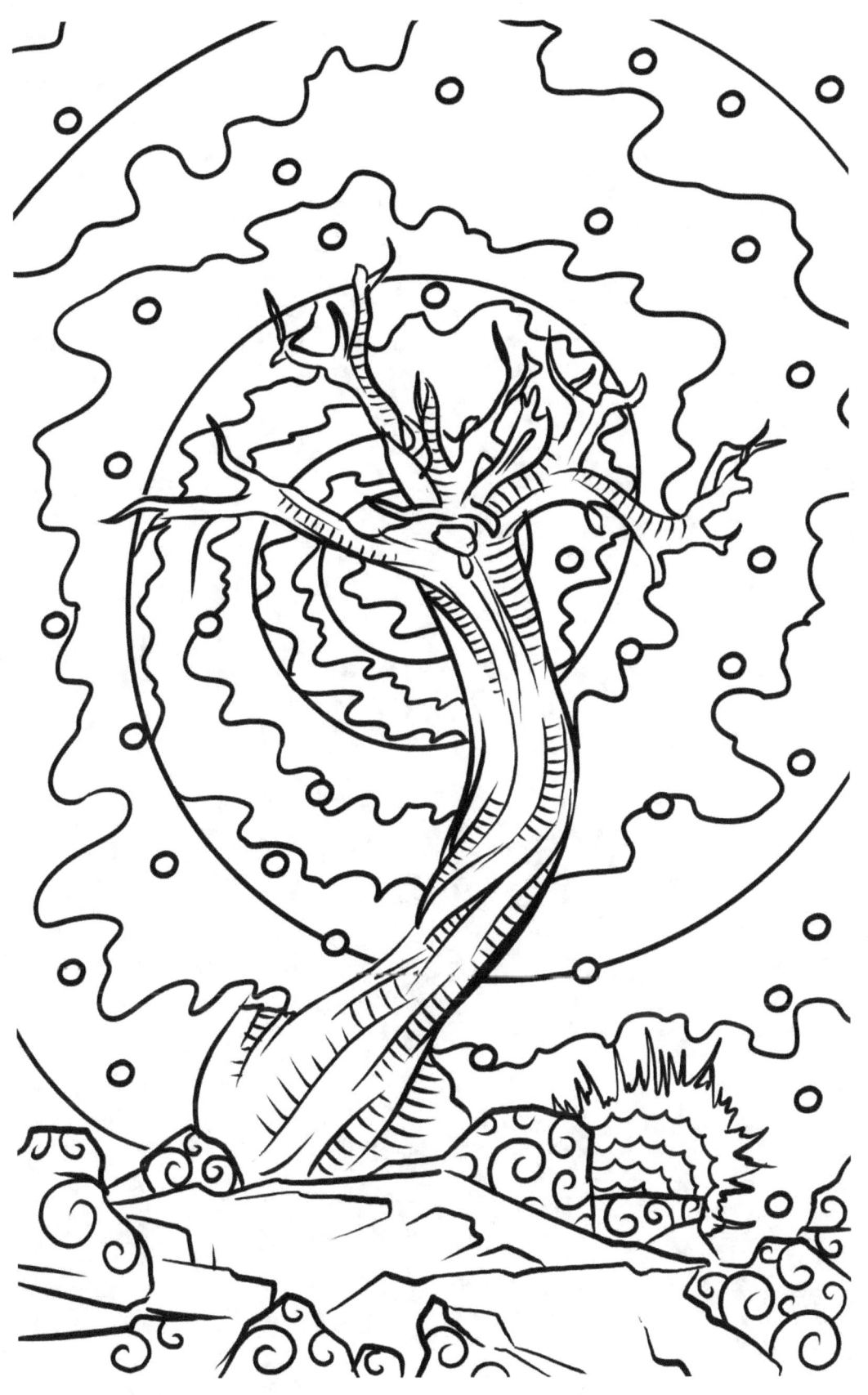

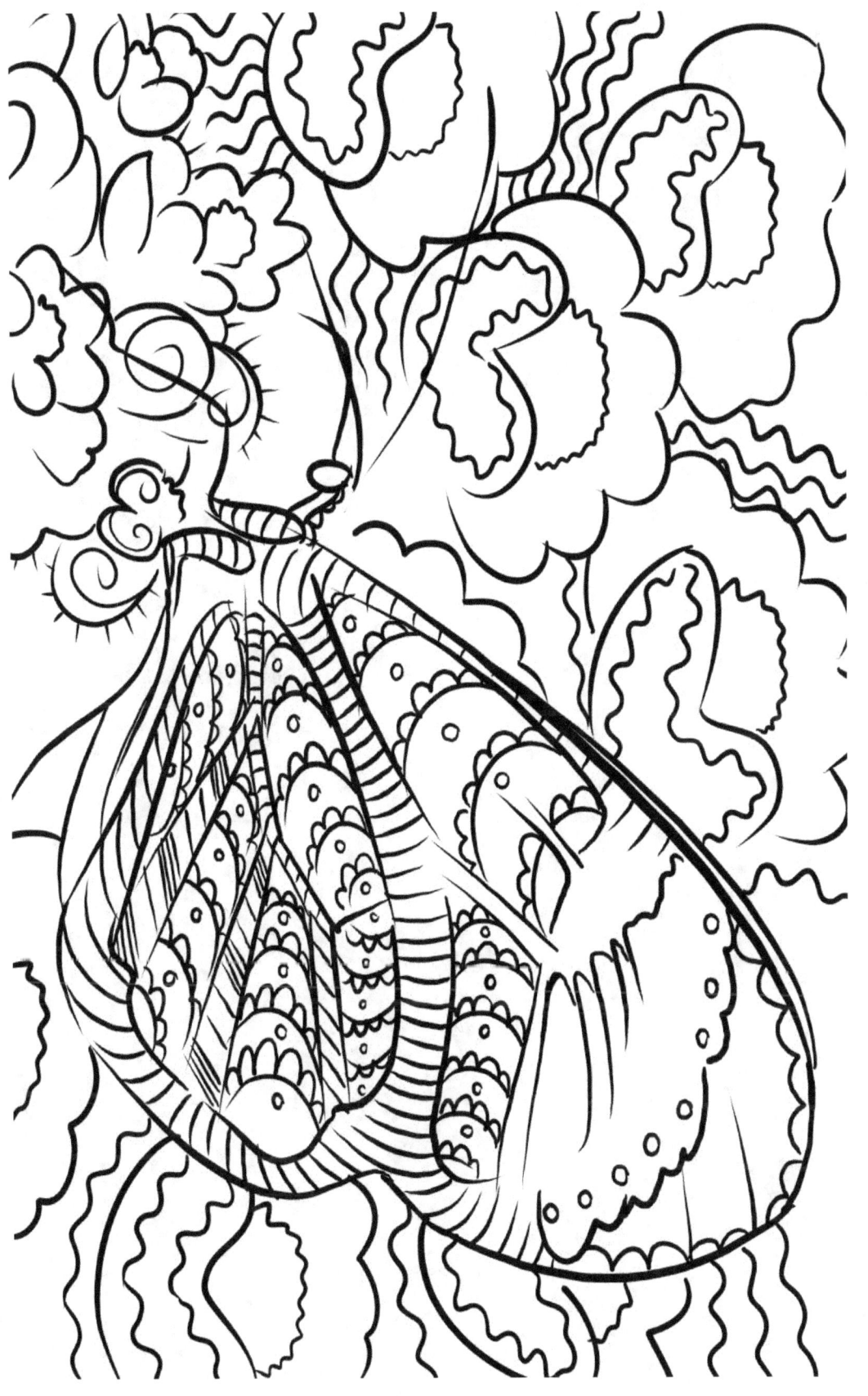

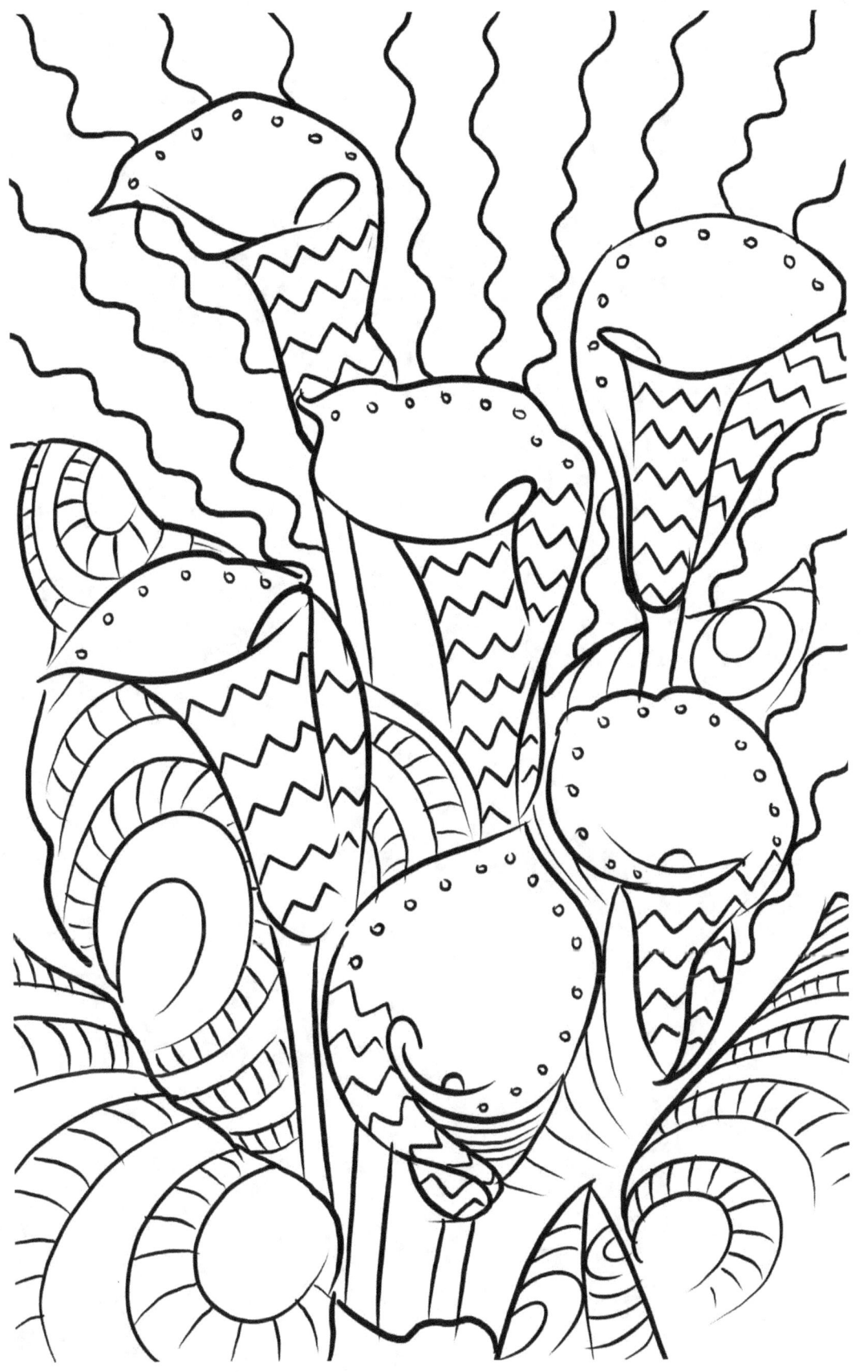

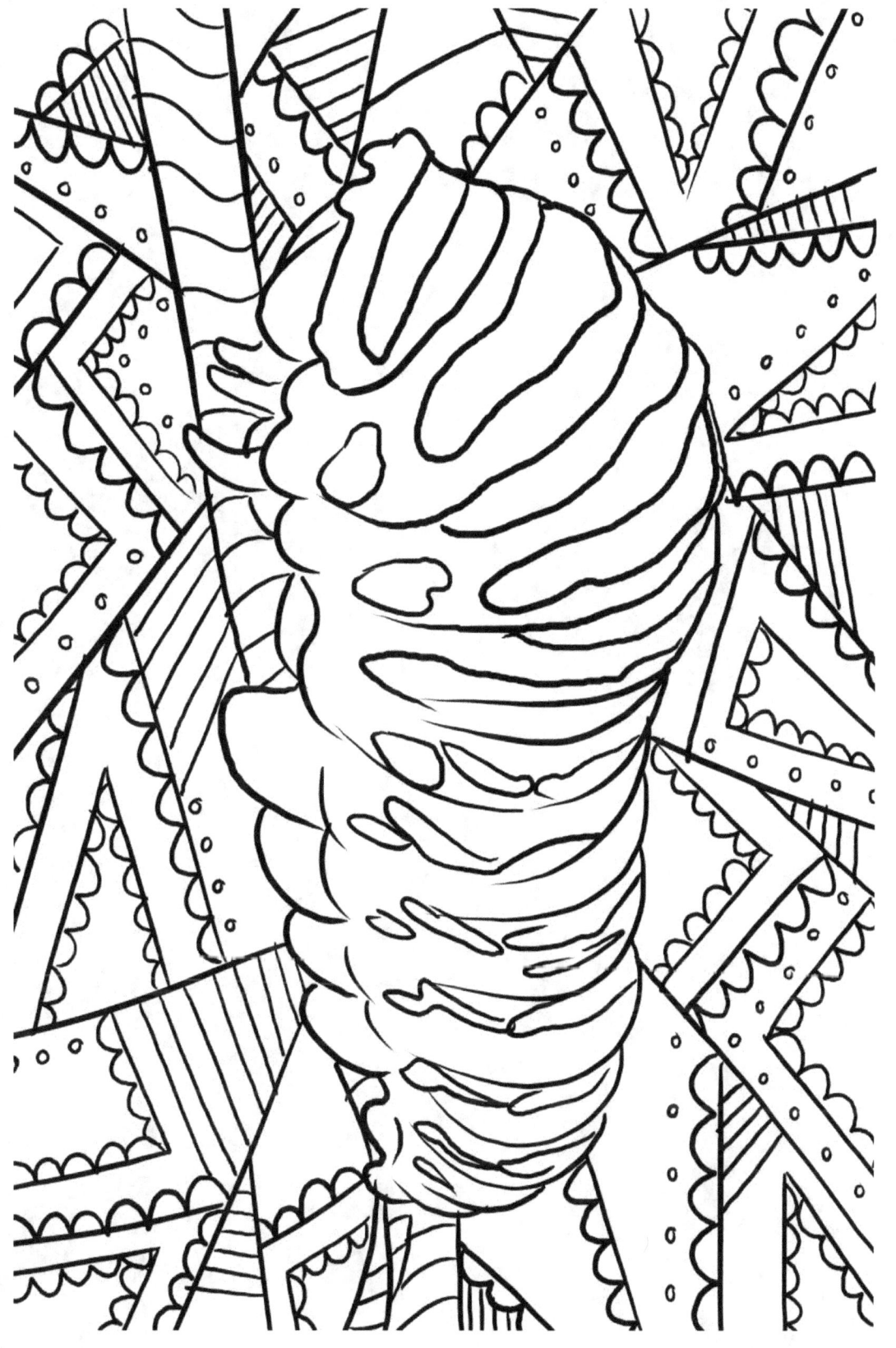

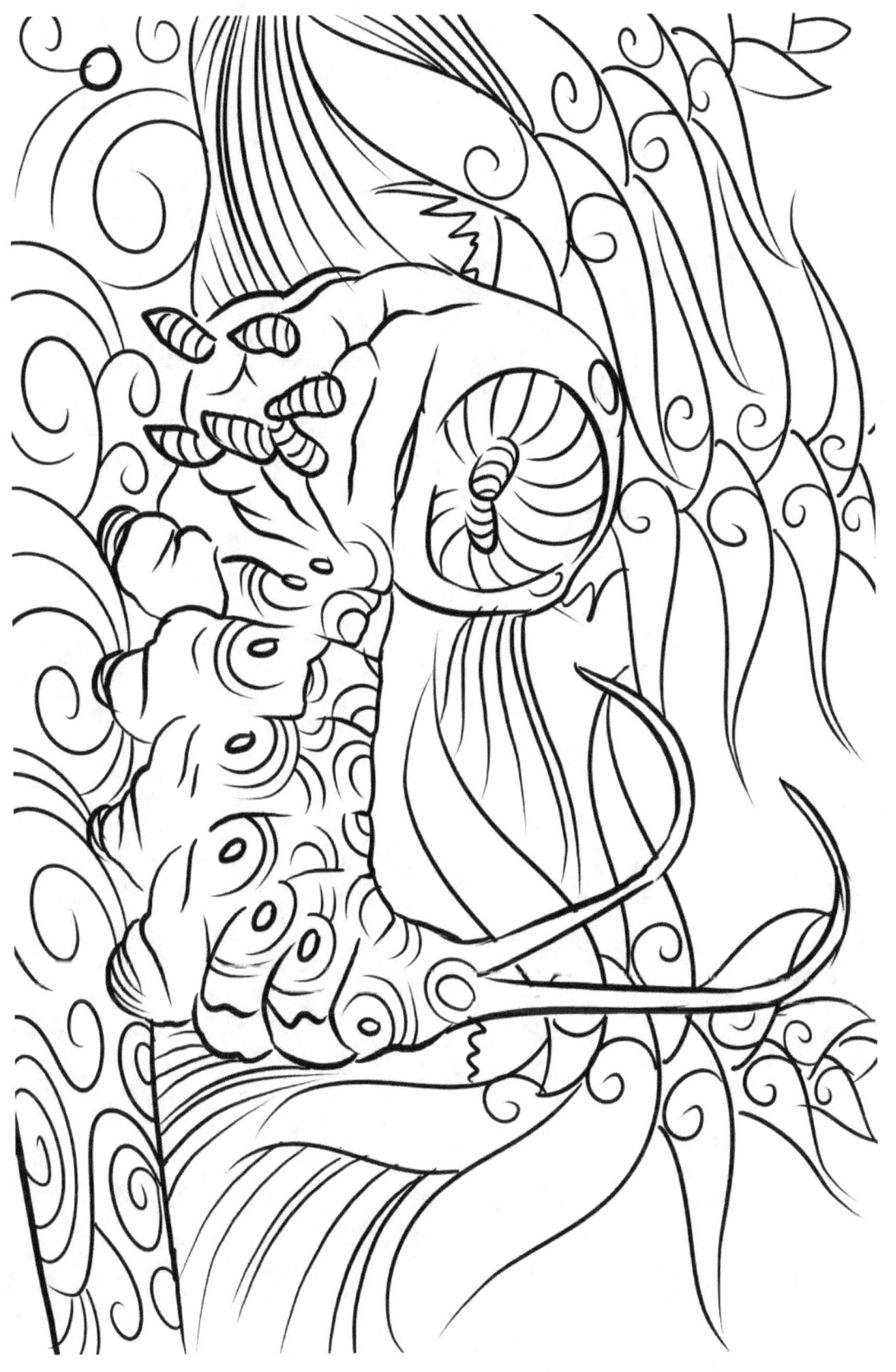

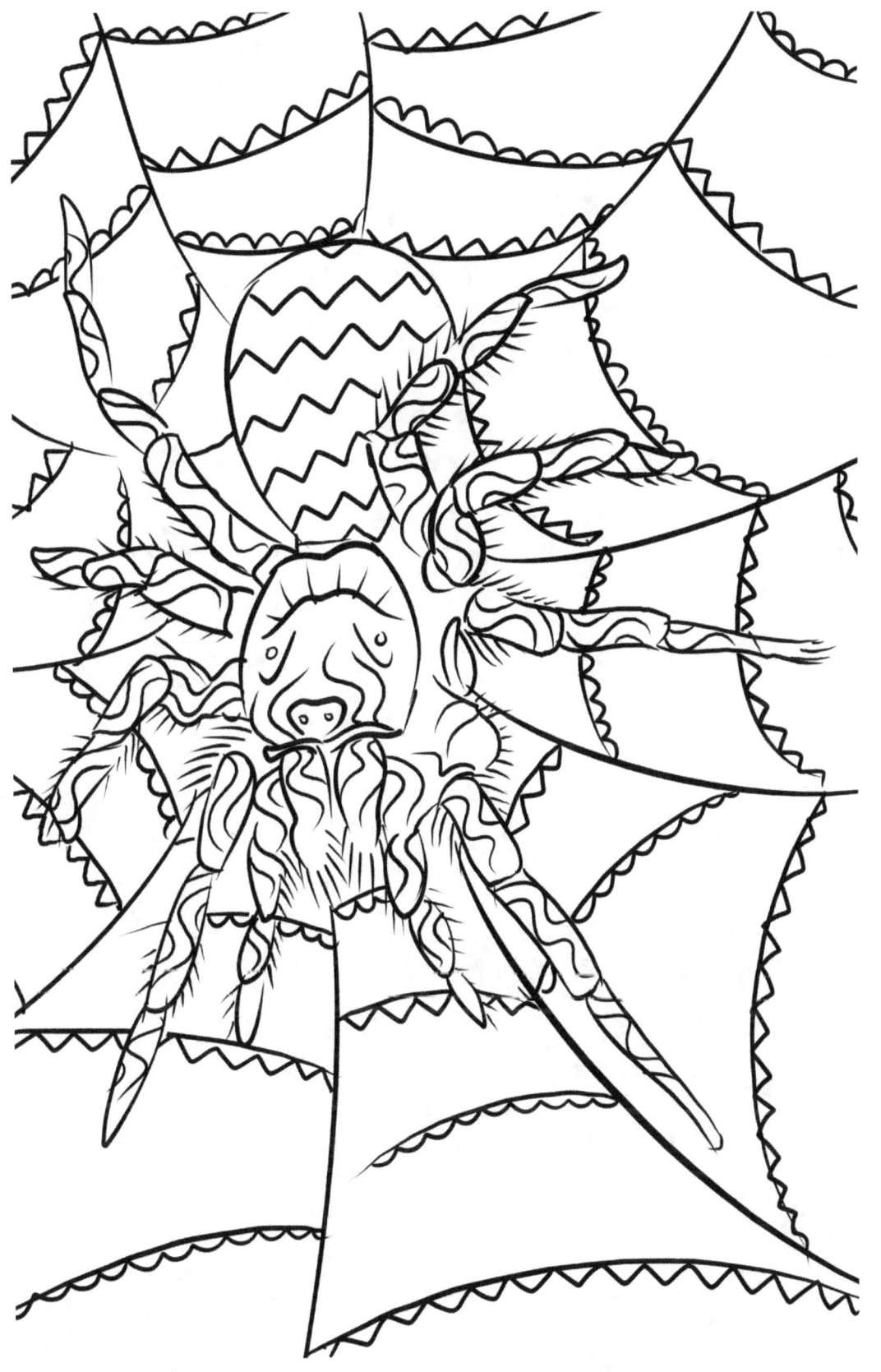

Thank you!

Thank you for choosing our book, we hope you found it interesting and helpful.

If you liked the book, please give us a favor to write your review.

We would really appreciate this!

If you would like to have a bonus – **FREE BOOK**, please send the screenshot of your review to this e-mail: **gloria.kemer@gmail.com** and we will send you a **FREE BOOK** in PDF as a **GIFT**!**

Hope to see you in our future books and good luck in your drawing experience!

** **in the e-mail subject please mention the name of the book you reviewed and the author.**

To get all the pictures in one PDF file to print it, please use this link:

https://drive.google.com/open?id=0B2v1XmtQAtt6MDB5aVQyclBFckE

Then download a file "101 colorings"

OR CONTACT ME

gloria.kemer@gmail.com

I'll send it to you :)

www.ingramcontent.com/pod-product-compliance
Lightning Source LLC
Chambersburg PA
CBHW081144180526
45170CB00006B/1929